SHOOTING & SELLING YOUR PHOTOS

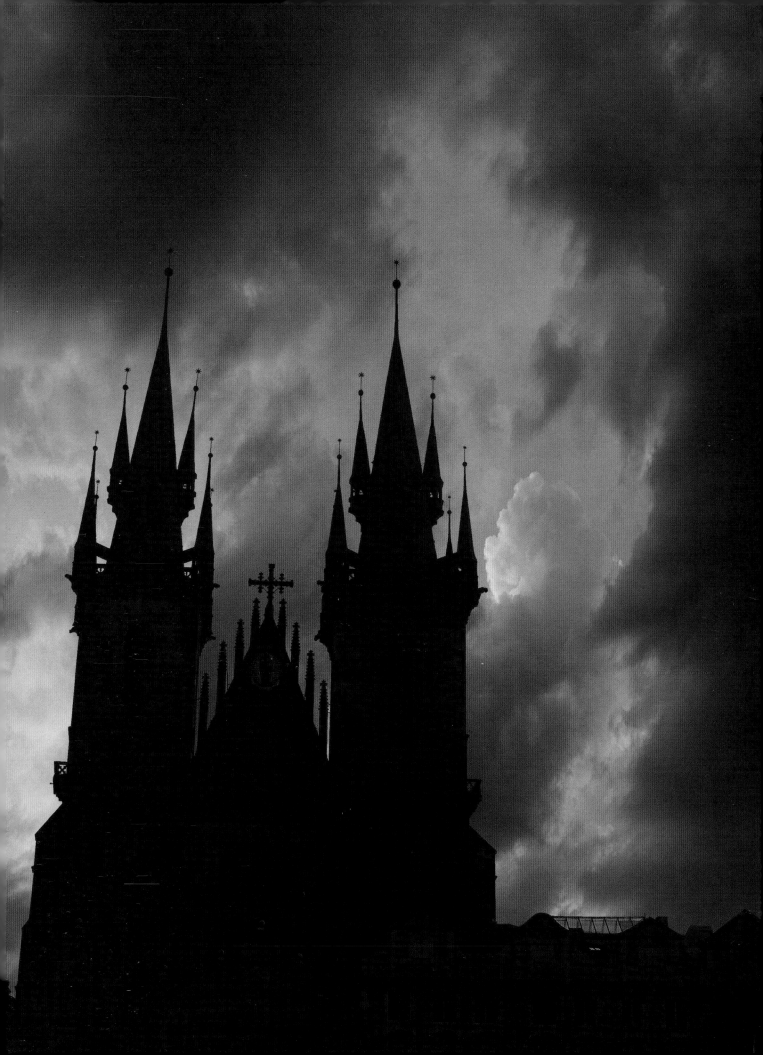

SHOOTING
&Selling *your*
PHOTOS

JIM ZUCKERMAN

WRITER'S DIGEST BOOKS
CINCINNATI, OHIO
www.writersdigest.com

dedication

To my wife, Indiana,
who has brought much joy
into my life.

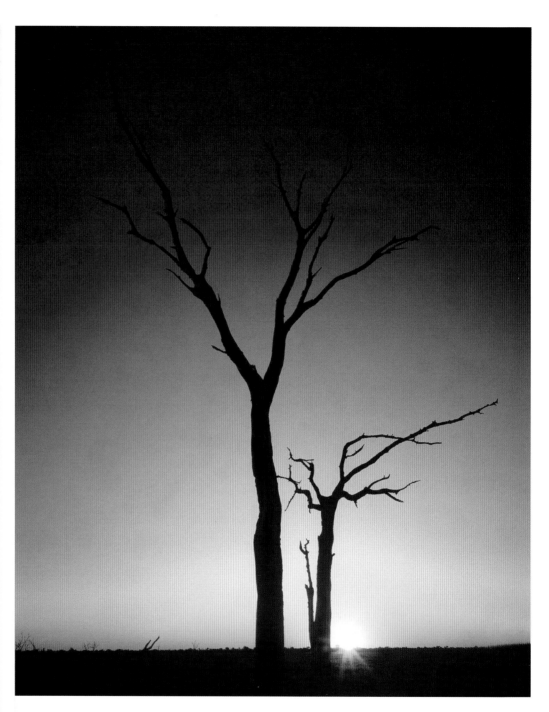

EDITOR: Jerry Jackson, Jr.
COVER DESIGNER: Joanna Detz
INTERIOR DESIGNER:
Brian Roeth
INTERIOR LAYOUT ARTIST:
Kathy Gardner
PRODUCTION COORDINATOR:
Michelle Ruberg

Visit our Web site at www.writersdigest.com for more information and resources for writers.

Other fine Writer's Digest Books are available from your local bookstore or direct from the publisher.

07 06 05 04 03 5 4 3 2 1

Cataloging-in-Publication data is available from the Library of Congress at <http://catalog.loc.gov>.
ISBN 1-58297-215-X

acknowledgments

Thanks to my editor, Jerry Jackson Jr., whose hard work and attention to detail helped make this book possible. And thank you to designer Brian Roeth for taking good care of my photographs.

Jim Zuckerman left his medical studies in 1970 to turn his love of photography into a career. He has lectured and taught creative photography at many universities and private schools, including UCLA, Kent State University, the Hallmark Institute of Photography and the Palm Beach Photographic Center. He also has led international photo tours to destinations such as Burma, Thailand, China, Brazil, Eastern Europe, Greece, Kenya, Morocco, Alaska, and Papua New Guinea.

Zuckerman specializes in wildlife and nature photography, travel photography, photo and electron microscopy, and digital special effects. He is a contributing editor for *Petersen's Photographic*. His images, articles and photo features have been published in scores of books and magazines including several Time-Life Books, National Geographic Society publications, *Outdoor Photographer*, *Outdoor and Travel Photography*, *Omni Magazine*, *Condé Nast Traveler*, *Science Fiction Age*, Australia's *Photo World* and Greece's *Opticon*.

about the author

contents

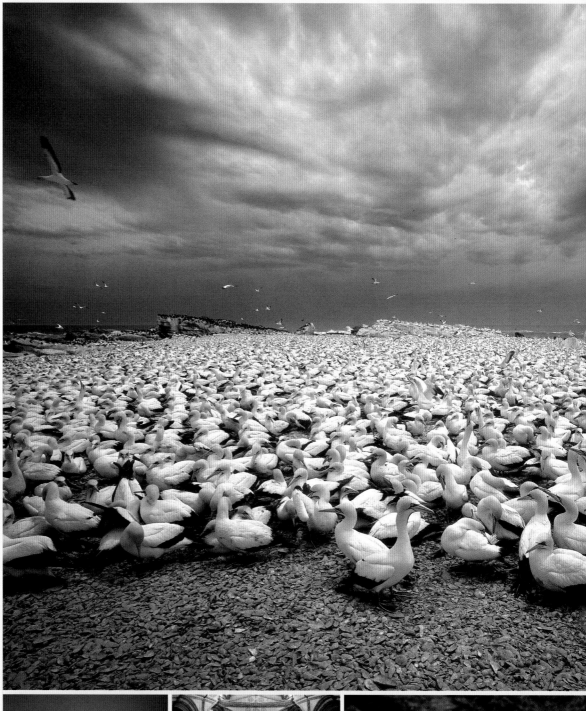

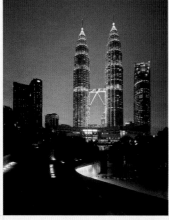

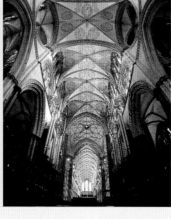

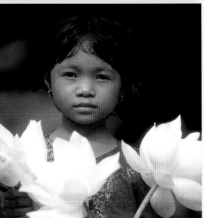

introduction

There are many people who have the same dream that you have. How do I know what your dream is? I know because you picked up this book and started reading. You would like to know how to turn your love of photography into a full- or part-time income.

To follow a dream is to give meaning to your life. My own life has been enriched beyond words by devoting it to the creation of wonderful photographs and sharing the beauty I see in the world with others. Unlike so many people in boring or repetitious jobs, I get up in the morning excited to go to work. My workday may consist of photographing a cave system in Borneo or a costumed dancer in Morocco. I may have to burn a CD for a submission to a magazine or write a children's book proposal. Maybe I'll be scheduled to teach a seminar in nature photography or work on the computer to create realistic dinosaur pictures for a calendar idea I have. Every aspect of this business is a pleasure for me, and I sympathize with those of you who dream of devoting your life to photography but don't know how to start.

That's why I wrote this book. I want to help you turn your passion for making images into a comfortable income. In the beginning, trying to market your work seems like a daunting proposition. You feel intimidated and insecure. You think, *How can I compete with all the pros who are already making a living and whose photography is so much better than mine?* The answer is this: There is always room in the marketplace for one more person who wants to learn and who is ambitious. And if you are persistent and can accept rejection with determination rather than defeat, you can achieve anything you want. This isn't just a nice little pep talk. It's the truth.

If you follow the steps I outline in the following chapters, you will definitely make money with your photography. Any new endeavor starts slowly, and you have to build on your successes and learn from the failures. I delve into many ways to market your work. Some of them will feel right for your temperament and your style of photography while others won't apply. For example, selling your work at art shows may sound like fun, but shooting for a stock photo agency doesn't feel right. Or selling prints on the Internet is something you would like to explore, but self-publishing seems too risky for you.

There are many ways to sell photos. After reading this book, you may come up with an idea that I never thought of. Great. Go for it. If nothing else, let this book inspire you in the belief that you can really do it.

are you ready to turn pro?

WHEN I DECIDED TO LEAVE MY MEDICAL studies and become a professional photographer, I had no idea what I was doing. I was clueless about operating a business, marketing my skills was a complete mystery, and my photos were—in retrospect—amateurish. The only thing I had going for me was an intense desire to make photographs.

If you are reading this book, you have the same passion. The question is, where do you go from here? How do you know it's time to start thinking about selling your work? Beginning a new career is an insecure proposition. Changing careers in midstream when you have family and financial obligations is a tough thing to do. The first step in the process, I believe, is to assess your strengths and evaluate your motivation.

PHOTO AT LEFT. To determine if your images are technically superior, examine them with at least a 4x loupe for medium- or large-format film and an 8x loupe for 35mm slides. Look for imperfections caused by the lab you're using, such as dust imbedded in the emulsion, scratches and fogging. Then determine if your photos are sharp, if the exposures are correct, and if you have appropriate depth of field for each subject.

EVALUATING YOUR PHOTOGRAPHY

The initial question you must ask yourself is this: Can I compete in the marketplace? Is my photography good enough to earn a part- or full-time income?

The best way to answer this is to compare your images with those of photographers making a living in your area of specialization or interest. The professional shooter with whom you compare your work doesn't have to be nationally recognized. He can be a local photographer who has a successful business. Or you may want to evaluate your work against someone who is very well known. In either case, here are the questions you should ask yourself when your work is placed side by side with the pro's photography.

1. *Is my work as technically superior?* Examine your transparencies or negatives closely with a magnifying loupe. Are the images sharp and well exposed, and do they have sufficient depth of field? Is the film free of dust and scratches, i.e., is the lab you're using clean?

2. *Are my compositions as strong and dramatic?* Do you have a variety of wide-angle as well as

Compelling subjects make successful images. This dramatic composition is Avalanche Creek in Glacier National Park. It is far from my home, but I traveled here specifically to make this shot because it's such a dynamic composition, hence very salable. This is the kind of effort required to make your portfolio stand out among the crowd. One outstanding photograph can sell hundreds of times during your career.

tightly composed telephoto shots? Do you use unusual perspectives? Do you use both bold graphics and images with soft lines?

3. *Are my subjects as interesting and compelling?* Do people who see your work react to your choice of subjects with emotion, surprise, appreciation, or curiosity? Do they want to see more?

4. *Are the backgrounds in my images comple-* *mentary to the subject, or do they fight with it?* When you look at your pictures, are you distracted by background elements? Do vertical lines, like poles and trees, seem to come out of people's heads? Do you use shallow depth of field to focus attention on a subject?

5. *What techniques is the pro using to make his or her images powerful that I haven't yet incorporated into my photography?* Study the images of

the work you admire, and make a list of the qualities you like. Does your work have these same qualities? If not, do you know how to change your shooting style to incorporate these ideas into your work?

If you have a hard time answering these questions, don't turn to a friend who isn't involved in the photography business and ask for an uneducated opinion. Your friend may mean well, but the feedback will most probably be irrelevant. Sit down with someone who can really help you, such as a magazine photo editor, anyone involved in an advertising agency, a photo instructor, or a successful photographer. And don't just rely on one person's insights. Get two or three opinions before you draw any conclusions.

FIVE STEPS TO IMMEDIATELY IMPROVE YOUR PHOTOGRAPHY

In conjunction with an evaluation of your work against that of a photographer whom you respect and admire, use the list below, which itemizes

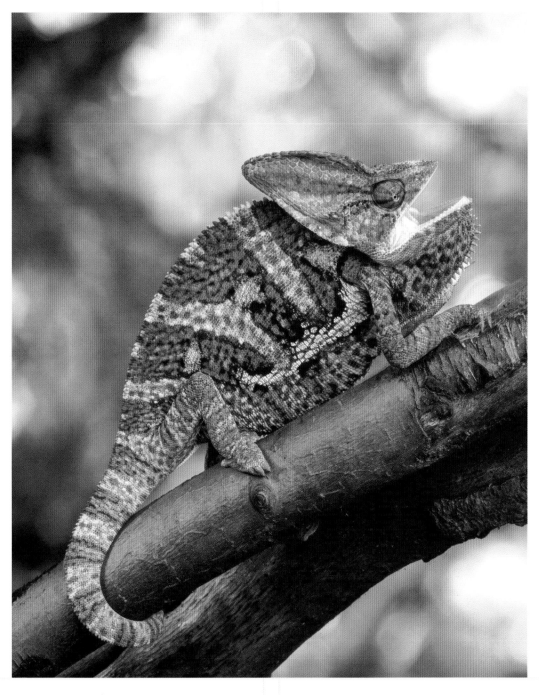

Pay special attention to the background. So often in the excitement of the moment, photographers forget to move their eyes around the viewfinder to make sure nothing intrudes on or takes attention away from the subject. Here the out-of-focus foliage forces all your attention on the chameleon. Had a single branch been sticking out from behind the reptile's head, the picture would be flawed.

techniques that will immediately improve your shooting. Some of the items are easy to do while others require practice and visual discipline. Don't gloss over this list and put it in the back of your mind. It will really help you if you incorporate these techniques into your work.

1. *Choose interesting and dramatic subjects.* This one idea is more important than anything else you'll ever read with respect to improving your photography. If you shoot people, they should have great beauty, strong character, humor, emotion, or tragedy. All faces are not cre-

ated equal; some make great photographic opportunities and some don't. Your choice will make or break the picture.

If you shoot wildlife, the animals in your compositions must be fascinating, beautiful, or intriguing. A gorgeous multicolored butterfly will make a better picture than a boring brown species, for example. Similarly, an intimate portrait of an African lion is simply more compelling than a portrait of your house cat. Yes, it takes more time, money, and effort to go on safari or otherwise find the most exciting subjects. But

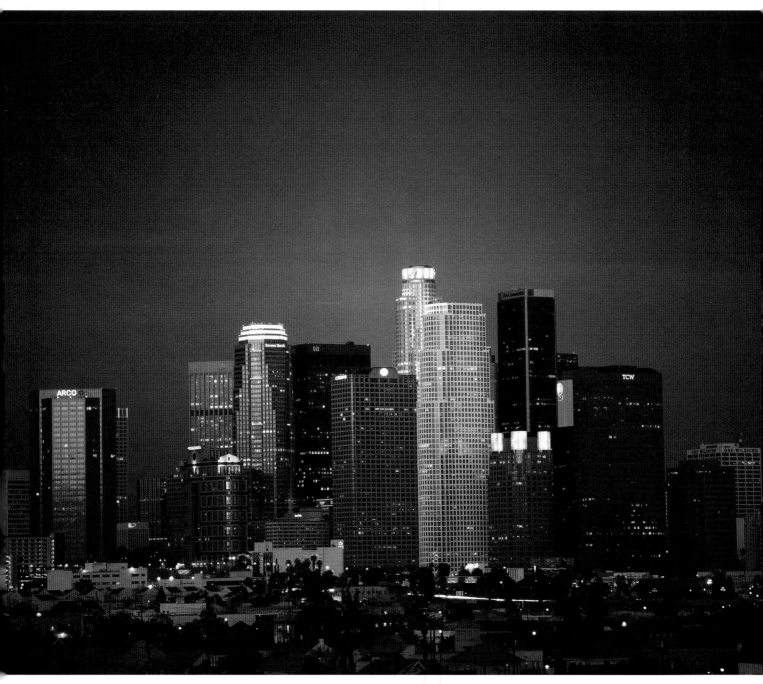

remember, you will be competing with the best photographers in the world. Photo buyers don't care how you get the shots; they just want the best.

The same idea holds for other subjects such as architecture, products, landscapes, and photojournalism. Photojournalists who win Pulitzer Prizes have done their definitive work during war, in insane asylums, inside hard-core prisons, with drug addicts, and with other emotionally gripping and visually compelling subjects. They didn't get the prize for covering political campaign speeches. The most dynamic subjects will draw attention to your work and place you a cut above other shooters.

2. *Use dramatic lighting.* When shooting outdoors, sunrise and sunset illumination are the most dramatic. At the opposite end of the spectrum is a cloud cover, which produces soft, moody light. Unless you are trying to achieve harsh, unattractive lighting, avoid a high, midday sun. If you shoot in a studio, become a master of light. Learn how to use a single light as well as multiple light sources. Use shadows creatively.

3. *Think as the lens sees.* Photography does not reproduce what we see with our eyes. A normal lens comes close, but wide angles and telephotos distort the way our brain interprets the world. You will dramatically improve your shooting if you can learn to see a subject as the lens sees it. Know exactly what an ultrawide angle will do to a person or landscape. See in your mind's eye the compression and out-of-focus background characteristic of a telephoto.

4. *Pay attention to the background.* Don't get so excited by the subject that you forget to look at

I first learned about the effectiveness of sunrise and sunset lighting in nature in the 1970s. I compared my landscape work with that of a well-known photographer I'd admired for years. His work was great; mine wasn't. When I studied a book of his photographs closely, I realized that most of his dramatic landscapes had been taken just after sunrise or just before sunset. When I incorporated this technique into my outdoor work, the transformation was immediate and dramatic.

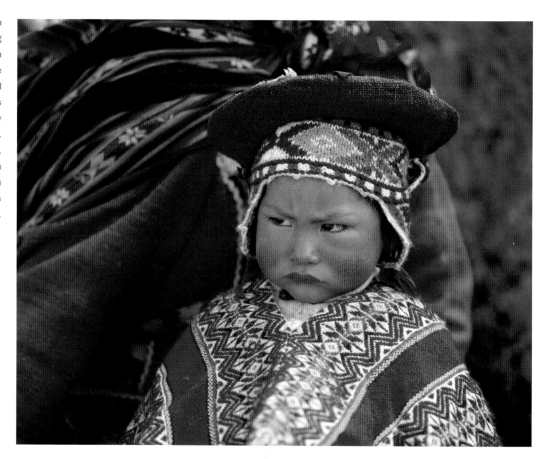

the background in the viewfinder. After you select a composition and the subject is positioned exactly as you want it, move your eyes around the viewfinder for a moment and study the background. Is it messy? Is anything sticking out behind the subject that may be distracting? If you move a foot or two to one side, can you hide an unattractive highlight or some other annoying part of the background?

5. *Juxtapose colorful subjects for impact.* Use interesting color combina-

Wonderful faces make great portraits. As a photographer, seek out those faces that will stir emotions in the people who buy your pictures. Beauty is only one characteristic to look for when you study people as potential subjects. Character, powerful eyes, ruggedness, and sadness can be others. In this portrait of a little girl on Venice Beach in California, I was drawn to her ethnic beauty and her complete innocence. I shot from a low angle to use the white sky as an unobtrusive background.

tions in your work because advertising is often based on strong color impact. For example, shoot a red butterfly on purple flowers. Or photograph a model in a neon blue outfit against a brilliant yellow background.

At the opposite end of the spectrum, use ultrasubtle coloration to show the diversity of your skill level and your vision. Shoot white on white, like a white violin on a white backdrop, to create a subtle product shot. Or make a stunning portrait of a blonde woman in a white bridal gown against white. Some of my favorite landscape work has been done in winter, when all the elements in a scene are enshrouded in snow.

EXAMINING YOUR MOTIVATION

Establishing a photography business takes a lot of work. Many amateurs fantasize about seeing their name and their pictures published widely. They dream of traveling to exotic places, photographing beautiful models, gaining behind-the-scenes access to major events, and experiencing other intriguing aspects of the business. What they

don't think about is the fourteen-hour days required to be successful, the stress of deadlines, the fear of a single technical glitch that can ruin a shoot and destroy a reputation, the changing marketplace with the accompanying financial insecurity.

To be successful, you must want to be a photographer with all your heart. You cannot be wishy-washy and make a half-hearted attempt at it. You can't take some nice pictures on your vacation and then expect to support your family on the money derived from your "shoot." So before you even think about getting into this business, examine your motivation. Are you so in love with photography that you will allow nothing to get in your way? Do you think you can forego the security of a regular paycheck to make a go of it? Can you cut your living expenses to a bare minimum while you develop your skills, accumulate equipment, build a portfolio, solicit clients, and get published? Are you patient? Can you think long term and accept delayed gratification?

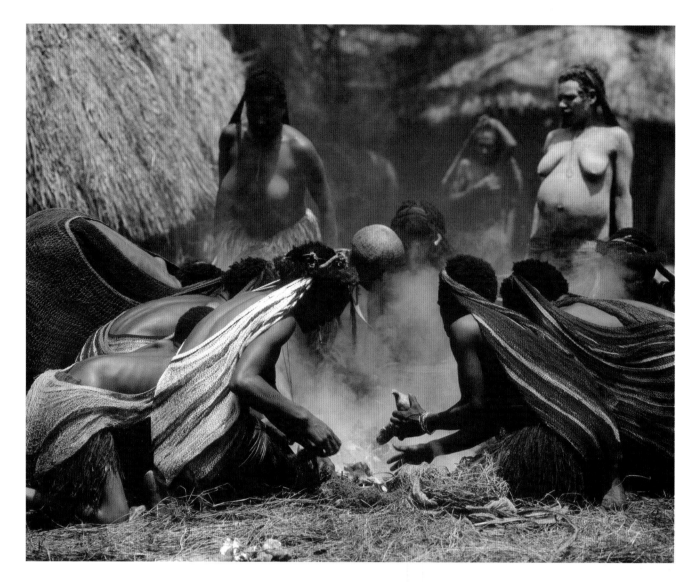

Learning how to "think as the lens sees" is an important skill that helps you previsualize the outcome of a composition before you look through the viewfinder. This shot of the Dani tribe in Irian Jaya, Indonesia, was composed with a telephoto lens because I was able to quickly see the tight composition in my mind's eye. I was standing at a distance and could mentally crop the scene such that I knew which lens to use—in this case my 250mm on a Mamiya RZ 67 II. In the 35mm format, this is equivalent to a 135mm medium telephoto.

These are all issues that I had to deal with as I was starting out in photography. I began when I was twenty-two years old; and I can assure you that my photography was not good, I was not patient, I had no long-term thinking, and I hated to delay any gratification coming my way! But I loved photography, and I knew how not to spend money. As I started selling my work, I gradually learned patience and long-term thinking. This allowed me to build a business with a sound footing over a period of years. But it was only possible because my motivation to make great images and to see them accepted in the marketplace was very, very strong.

In every endeavor in life, there are always obstacles. Often these roadblocks seem impossible to surmount. The photography business is no different. The competition is fierce, there are

many great photographers, advertising budgets get cut, the economy slows down, your insecurities sometimes incapacitate your ability to promote yourself, and on and on. All I can say to help you move forward when you feel paralyzed is that there is always room for one more talented photographer. If enough people see your work and it fills a need for just a few of the photo buyers who give you the courtesy of reviewing your portfolio,

PHOTO AT RIGHT. Previsualizing how a wide-angle lens views the world is equally important. Sometimes when things are happening quickly, as in this parade in Brugge, Belgium, you don't have time to study various compositions through the many lenses you carry. As soon as I gained access to the second-story window above the parade, I realized a wide angle would give me the coverage and perspective I wanted. I used a 50mm on the Mamiya RZ 67 II, equivalent to a 24mm in the 35mm format.

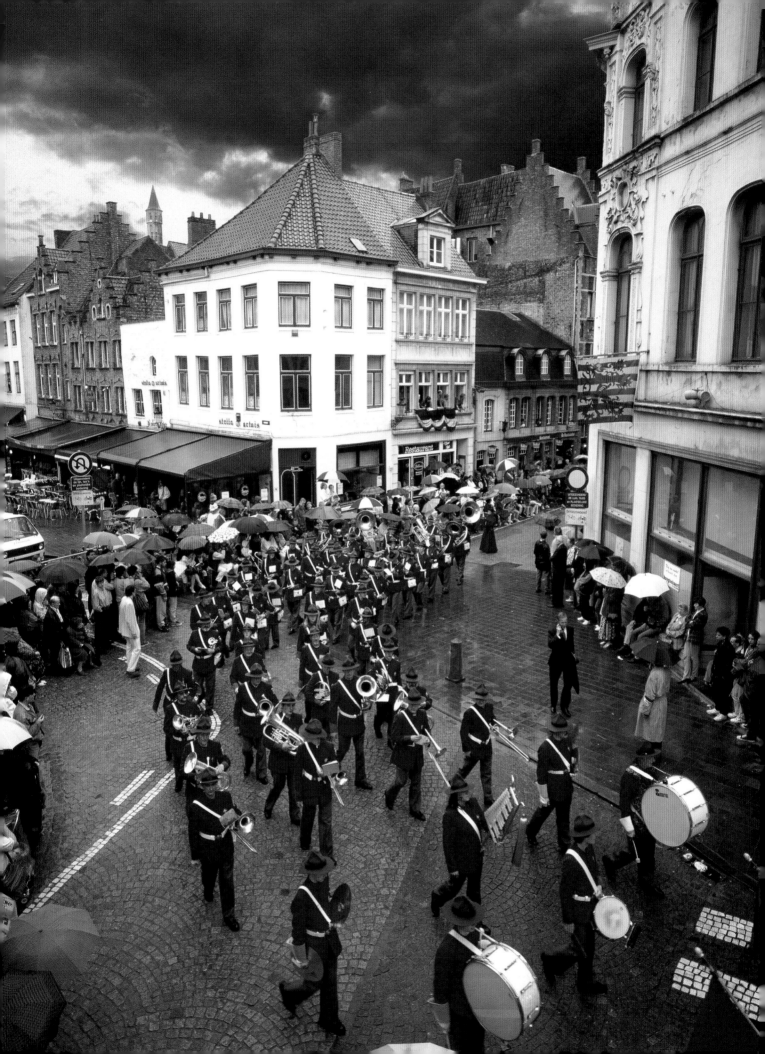

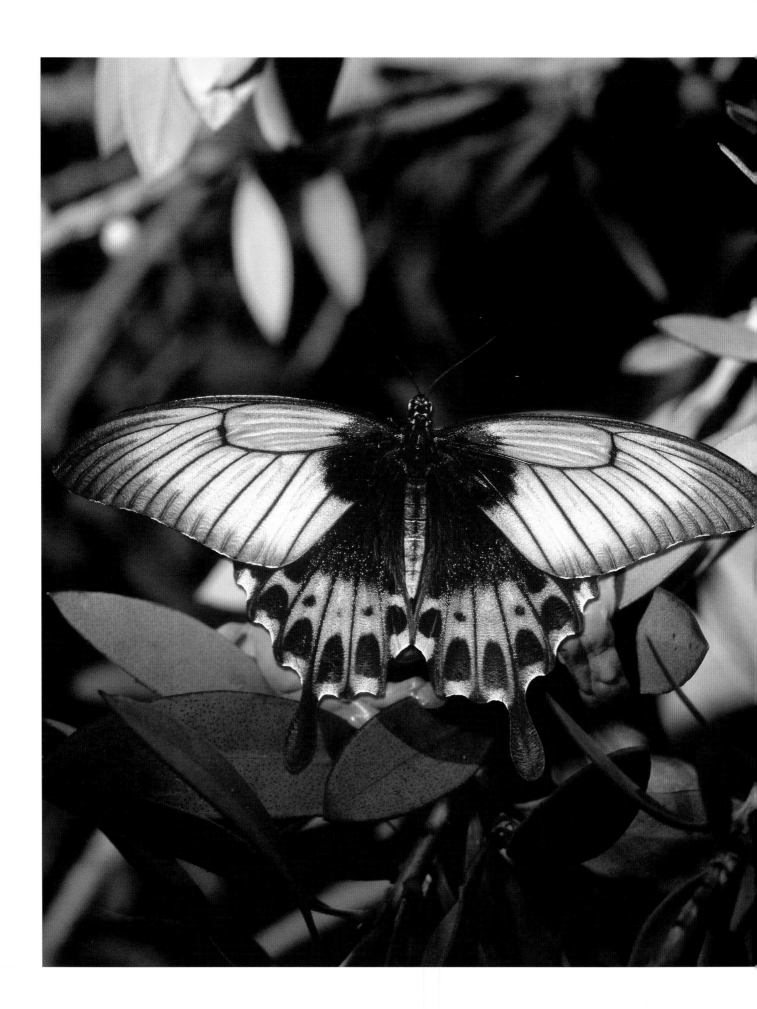

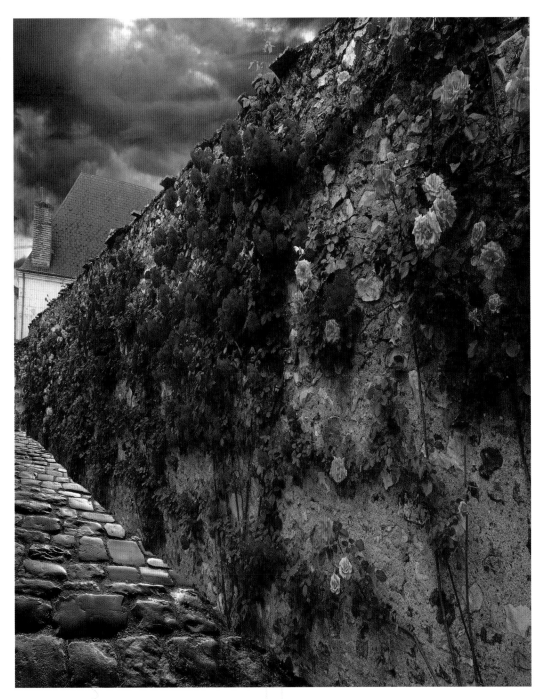

Compelling pictures that make your work stand apart from that of other shooters aren't necessarily unmanipulated. In most cases, the marketplace doesn't care how you made the picture. Photo buyers only care that it serves their needs. This picture is made from three components: the wall of flowers, the sky, and the cobblestones. They were assembled in Adobe Photoshop. If you are making a living at photography, you don't have the luxury of being a "purist." A sale is a sale. If a client wants to pay a thousand dollars for an image of yours but wants the sky replaced, are you going to say, "No thanks, I don't manipulate my images"? Don't be ridiculous.

PHOTO AT LEFT. Many years ago when I tried to determine the differences between my work and that of the photographers I admired, I realized that they were shooting fantastic species in the animal kingdom, going to exotic places, and capturing breathtaking landscapes. I was only shooting around my home. As soon as I began traveling and seeking out new subjects, my images took a quantum leap forward in excitement and salability. Great photography often means a great subject.

This shot of an exotic butterfly from the Philippines requires the same technical and artistic skill as a photograph of a nondescript brown butterfly taken in Arkansas. The only difference is the choice of subject.

you'll be on your way.

I want to make one last important point on this subject: Don't take rejections personally. I know it's easy to say this, but it is simply a numbers game. Your chances of making a sale increase the more you show your work. If for some reason your portfolio isn't appropriate for a particular buyer, simply go on to the next potential client whether or not you feel dejected and give it your best shot.

Perseverance is how everyone succeeds.

finding the subjects
that sell

AT FIRST YOU MAY THINK THIS CHAPTER IS not as important as subsequent chapters where I discuss getting into a stock photo agency, promoting your work with a Web site, building a portfolio, and so on. The truth is, however, this chapter is the most important one in the book. Without a library of dramatic, visually arresting photographs, you can't compete with other shooters. This chapter is designed to point you in the right direction from the beginning.

SALABLE SUBJECTS VS. NONSALABLE SUBJECTS

If you were old enough in 1962 to have taken a candid picture of Marilyn Monroe intimately whispering something in the ear of President Kennedy, it would be considered worthy of a Pulitzer Prize. You could probably retire on the income generated from that single shot. But if you had taken the same kind of image—using the identical light, the same unobtrusive background with the same sense of implied romance—of your best male friend and his girlfriend, it would have no value except to the subjects in the photo.

And you could kiss the Pulitzer good-bye.

What's the difference? With all things being equal, the difference is the subject. That is why this chapter is so important: I help you find subjects and themes that sell.

It is important to take pictures of subjects that are compelling, fascinating, colorful, rare, imposing, artful, humorous, famous, or beautiful beyond compare. Anything less won't compete well in the marketplace.

This doesn't mean that less-than-spectacular pictures won't sell. Many do. But to watch your income grow, you must seek out subjects that are guaranteed winners. These kinds of images sell over and over again in stock photo agencies, and they become your trademark.

Below is a list of comparison subjects that make my point. The first photo in each pair is obviously more salable than the second one. Think about each example with respect to the images you have pursued in the past and the types of subjects you might want to photograph in the future.

- A brilliantly colored butterfly vs. one that is dull brown
- A graphic, gnarled tree vs. a tree that is a tangled mass of branches
- An S-curved sand dune vs. low dunes punctuated with shrubs
- A baroque cathedral interior vs. an unadorned concrete chapel
- A portrait of an old woman with a weathered face vs. a middle-aged woman with uninteresting features
- A rhino drinking at a water hole vs. a waterbuck drinking
- The Grand Palace in Bangkok with fireworks behind it vs. the city hall in Bakersfield, California with fireworks
- A roseate spoonbill vs. a robin
- A portrait of a painted face from Papua New Guinea vs. a normal portrait from the United States
- An egret displaying breeding plumage vs. an egret without the display

Your income is directly proportional to the impact of your photographs. Are powerful images more difficult and often expensive to find? Of course. If they were common, they wouldn't have such value. Travel, research, patience, ingenuity, and lots of time are often required to take these kinds of photos. Your rewards, however, will be increased sales as well as the satisfaction of creating breathtaking imagery.

So, how do you find great subjects? Each of the following sources has provided me with dramatic photos that I have sold over and over.

The Internet

My first book on the business of photography (*The Professional Photographer's Guide to Shooting and Selling Nature and Wildlife Photos*) was written in 1989. It didn't even mention the Internet as a resource because few people understood its potential and it hadn't become a worldwide phenomenon yet.

Today it is the most powerful research tool we've ever had. I use it all the time to find photo-

graphic locations, interesting subjects, seasonal information, cultural events, weather conditions, and so much more. If you are not connected to the Internet in some way, it's time to expand your horizons and join the world community.

Let me give you five examples of how I used the Internet to find very salable subjects.

1. In my travels I met someone who told me that there was a butterfly farm on the island of Bali in Indonesia. I didn't know if in fact this was true; and if it was, I didn't know how to find it. I searched on the Internet for butterfly Web sites and found a bulletin board visited by butterfly enthusiasts. I asked if anyone knew of a butterfly farm on Bali and what the address might be. Within twelve hours I received an e-mail from a man in Taiwan with the name and address of the facility.

2. I was planning a trip to northern California to photograph the Sonoma Coast near Bodega Bay. I searched the Net for Web sites with photographs, trying to find specific locations where I could shoot. I found one Web site with some great images and e-mailed the photographer, asking if he'd share his locations with me. He was very generous with his information, including detailed directions to a specific beach that helped me get some wonderful shots.

3. I was traveling to South Africa, and I wanted to photograph some of the tribal people in their native environment and traditional clothing. Using Google as my search engine, I typed in "South African tribes." One of the Web sites I found was a cultural center an hour from Johannesburg that had programs featuring five different tribes. This was definitely oriented to tourists, but I knew very well that with tight cropping the pictures could look very authentic. Having five tribes in one place saves a great deal of time and money, and I also found out this facility offered overnight accommodations. I made a reservation from home via e-mail and had a great photographic experience when I arrived in South Africa.

4. To safely photograph poisonous reptiles, shoot them in captivity. While checking out vari-

ous Web sites, searching for people who owned snakes, I was referred to a man in Florida who had many species including an albino cobra, desert pit viper, green mamba, and Gabon viper. I called him and for a small payment arranged a photo session.

5. I was hired to help an American photographer living in the Philippines improve his photography. He wanted to travel to the island of Borocay to shoot and promised me that it was an island paradise. I knew nothing of this island, so I searched the Internet and found that they held an annual festival that would be great to photograph. However, my time there would make me three weeks late for the festivities. When I arrived at our hotel, I asked the concierge if he could arrange a photo session with a few of the dancers in the festival. The resulting images are among my all-time favorite travel pictures.

These examples show how compelling and marketable subjects can be found using the Internet. Anything you could possibly want to research is there, and the information is frequently accompanied by photos that give you a visual idea of what to expect.

Calendars

I've used calendars for many years to help me locate salable subjects. It's obvious that all the locations and subjects in the calendars are salable because the photos are, in fact, published. And usually the images are among the best representations of a particular place. Calendar prices are reduced significantly toward the end of January each year, and I purchase many of them to file for future use when I'm looking for places or subjects to shoot. I only buy the calendars that identify the location of each photograph.

Magazines

I subscribe to many magazines that are invaluable resources for subject matter. Even though a magazine runs a particular story, that doesn't mean other publications won't use the same story line with new photos. I have sold dozens of articles this way.

For example, years ago, when the monarch butterfly migration was first studied, *National Geographic* published a wonderful article on this spectacular event. A year later, I traveled to Mexico to photograph several overwintering sites used by the monarchs and then sold my own article and photos to two noncompeting magazines. Those same pictures of monarchs have also sold through my stock photo agency.

Every month, photography magazines are full of subject ideas and interesting techniques. I keep three distinct files for pages I tear out of magazines. One is for interesting photographic techniques; the second gives me ideas for salable subjects; and the third offers suggestions for unique shooting locations.

Cable TV

Educational programming on cable television has many programs devoted to wildlife, nature, history, travel, and science. These wonderful programs open the world to us. You may see a particular show devoted to a subject that, if documented well, could be turned into a book, a series of magazine spreads, or a one-man calendar. In addition, the same images might sell well in a stock photo agency or in a gallery exhibition.

Museums

There are many kinds of museums in the United States and throughout the world. The collections in these institutions range from fossils to dolls and from cowboys to classic cars. I would be willing to wager that you can find at least one collection in each museum that would make a salable photo/article package for more than one magazine. With permission from the museum, you could photograph their collection and submit these photos for publication. Usually museums only want a credit line for the publicity.

Several years ago I visited the Cowboy Hall of Fame in Oklahoma. At the time they were exhibiting part of John Wayne's kachina doll collection. I took a number of photos of individual dolls and submitted the idea to *Westways*, the publication of the Automobile Club of Southern California.

After obtaining permission from the museum, as well as getting caption information from them, the magazine ran the story because the subject matter was visually interesting, historically significant, and connected to a beloved celebrity.

Other subjects I have photographed in museums include dinosaur bones and fossils, beautiful gemological specimens, archeological stone art, ivory carving, King Tut's gold mask, and authentic shrunken heads from the Ecuadorian Amazon. If you make friends with the museum's curator and show an avid interest in the collections, my experience has been that photographing anything on display is not a problem. Many museums also have large collections in storage rooms that may also be accessible to you.

Researchers

In every scientific discipline there are men and women working on research projects. These people are either working on their advanced degrees or they are funded by grant money, and many times professional photographs can help them document or support their research. I have personally worked with Ph.D. candidates in the fields of marine biology, ornithology, and entomology; but you don't have to limit yourself to wildlife when looking for access to fantastic subject matter. Archaeology, anthropology, ethnomusicology, botany, paleontology, volcanology, and so many other "ologies" can be pursued this way. Contact universities and speak with the head of the department that interests you. Inquire if she can refer you to a researcher who might be receptive to working with you in exchange for good photographs.

Shooting Themes

Many photo buyers want to see a body of work built around a particular theme. The subject matter you choose could be practically anything. If you had a series of digitally manipulated frog pictures showing them enjoying leisure activities (sunning themselves on the beach in sunglasses, playing golf, etc.), this would be considered a unique and marketable theme. Collections of

wild orchids or albino animals are other possibilities. Below is a list of twenty themes (this is only the tip of the iceberg). Any of them can be quite remunerative for an ambitious photographer. I say "ambitious" because each specialty in photography requires a serious commitment and a serious expenditure of energy over a long period of time. However, if you are following your passion, it's really not work at all. It's a joy to pursue what you love to do.

Sailboats
Landscapes
Cathedral ceilings
Puppies and kittens
Above the timberline
Animal humor
Horses
Unicorns (obviously digitally altered horses)
Flower gardens
Nudes
Dancers
African ceremonies
Brides around the world
Endangered cats
Outrageous architecture
Sacred places
Marine life
Owls
Ancient tombs
Ancient ruined cities

Focusing on a single theme or related ideas forces you to be very creative. You don't want to have a collection of images that are visually boring; so you should explore various techniques, lenses, angles, and types of lighting. Let's take one of the themes above and I'll show you what I mean.

One of my favorite themes is sacred places. I appreciate stunning architecture and art and am fascinated by monuments raised to the beliefs of Man. Throughout my travels, I always seek out these places.

The twelve photographs shown on pages 32 and 35 exemplify only a small portion of my stock

representing this subject matter. Notice several things about the collection. First, there is a diversity of color. Next, I choose pictures taken at various times of the day and under different weather conditions. I also cover different aspects of each place, including details, long views, and upward shooting angles; and I shoot both horizontal and vertical compositions with both wide-angle lenses and telephotos. It is important to produce visually stimulating layouts; and as I take pictures, I try to offer a photo editor a large selection from which he or she can design the article.

Keeping Up With Trends

Photographic styles change. Sometimes these changes are rapid and sometimes they occur over the course of a decade. The "in look" in any particular year may be shocking color, contrasty black and white, motion blurs, overexposed and out-of-focus images, unorthodox compositions, dark and somber tones, surrealism, sepia toning, lighting ala the 1940s, or many other styles, some of which have yet to be popularized. It is important for all photographers to be aware of these changes, but it is particularly important for stock photographers and shooters involved in advertising to follow these trends. Your income may depend on it.

The best way to educate yourself with respect to changing styles is to subscribe to many magazines that publish avant-garde and cutting-edge imagery. These include fashion magazines (filled with scores of ads and trendy fashion layouts), photo magazines like *American Photo*, publications devoted to the latest digital techniques, slick corporate annual reports, and travel magazines. Keep a file of articles and advertisements that not only stimulate your creative juices but educate you with respect to the latest trends. The published photos you see are by definition important because companies with large advertising budgets chose those images with great deliberation.

An example of what I'm driving at can be seen in print ads depicting romantic couples on a tropical beach. For many years you would see youngish people frolicking in the surf or embrac-ing each other against a setting sun. But now you can see billboards and magazine ads that convey the same message with a photograph showing only their feet in the sand, perhaps with a trail of footprints. Sometimes selective focus is used, where the depressions in the sand are sharp but the feet of the models are softly blurred.

Nature photographers go to great lengths to take critically sharp pictures, but publications looking for a new look may experiment with creative blurs that imply motion: a yawning lion, a herd of running antelope, autumn foliage blowing in the wind. Digital techniques may be used with a couple on safari—sharply rendered—who are looking at out-of-focus animals at a water-hole. Or vice versa, where the couple is soft but the animals in the distance are sharp.

I am not suggesting you copy the work of other photographers; but your work can be influenced by current trends, especially if you want to appeal to the young and aggressive art directors and photo buyers who want to call attention to their product or service through a variety of visually stimulating techniques.

These photos resulted from research I did using the Internet. I photographed the desert pit viper in captivity, the jackass penguins thirty minutes from Capetown, South Africa, the dancers in the Philippines, and the female Madagascar moon moth in someone's garage all because I searched the Net and then contacted people who helped me gain access to these subjects. You have the world at your fingertips when you're online, and the salable subjects you can locate using this incredible resource are virtually infinite.

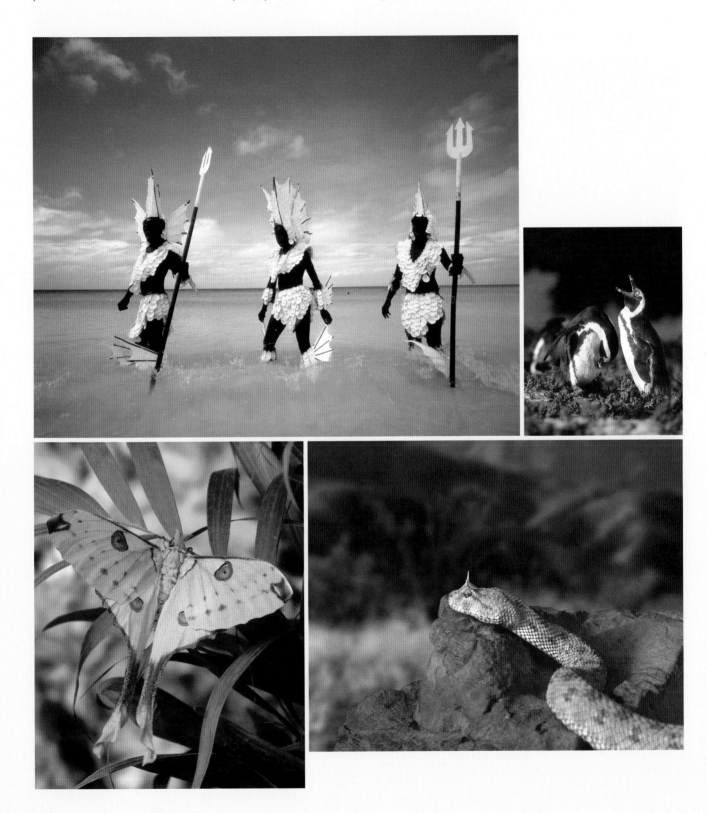

These nine pairs of comparison photos illustrate my point that your choice of subject matter is paramount in selling your work. None of these shots are technically flawed. However, the second photo in each pair is much more dramatic and therefore more salable than the first shot. The difference may be color, form, weather, or a more compelling face or clothing. My point is that good photos of less compelling subjects may sell, but it will be difficult to make a living unless you photograph things that make people sit up in their chairs and say "wow." This takes more effort, but it will make more money for you.

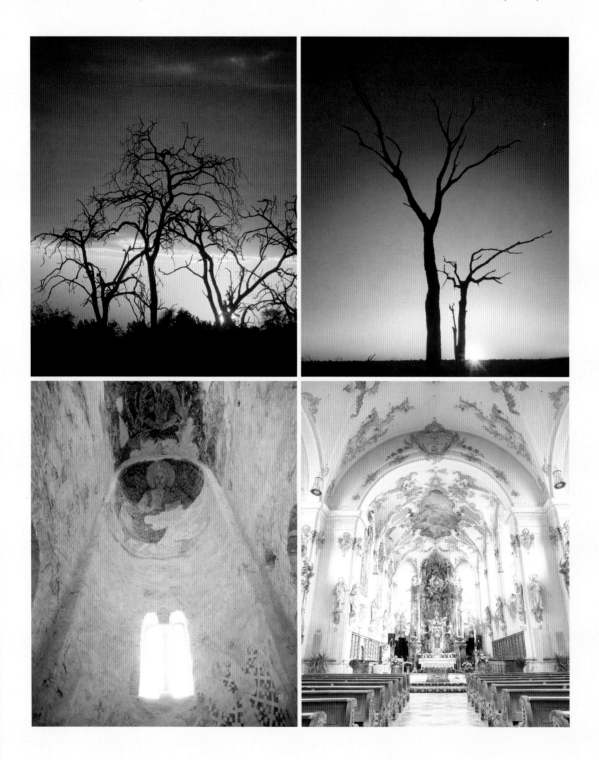

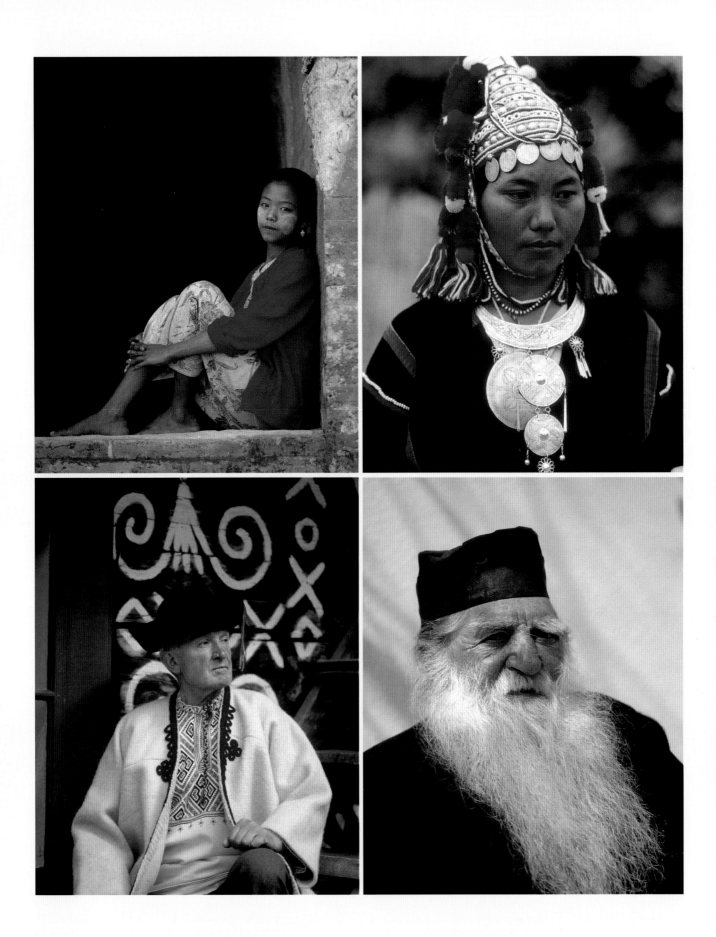

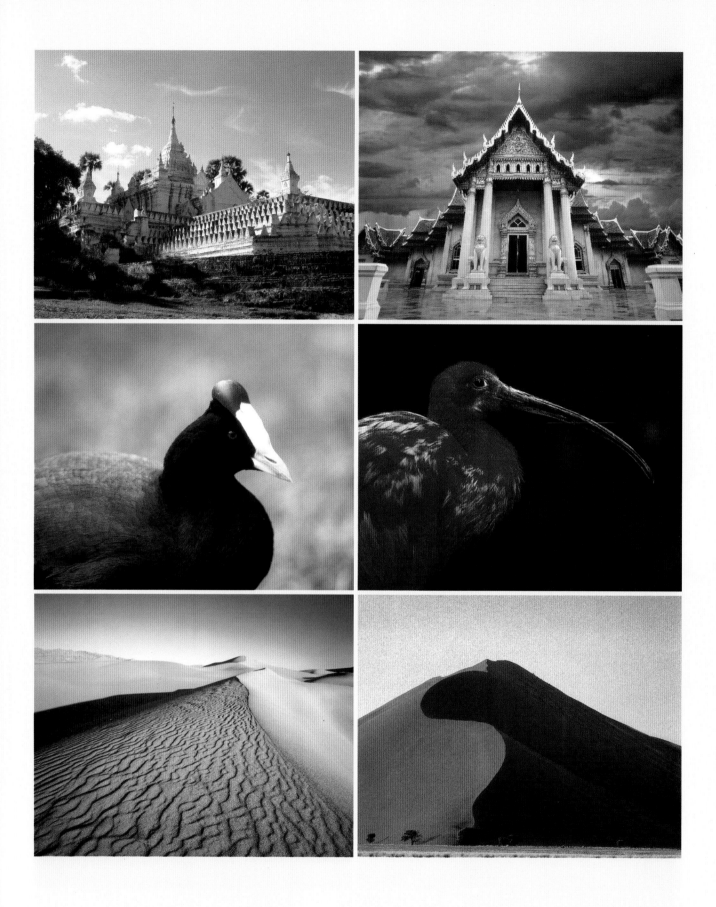

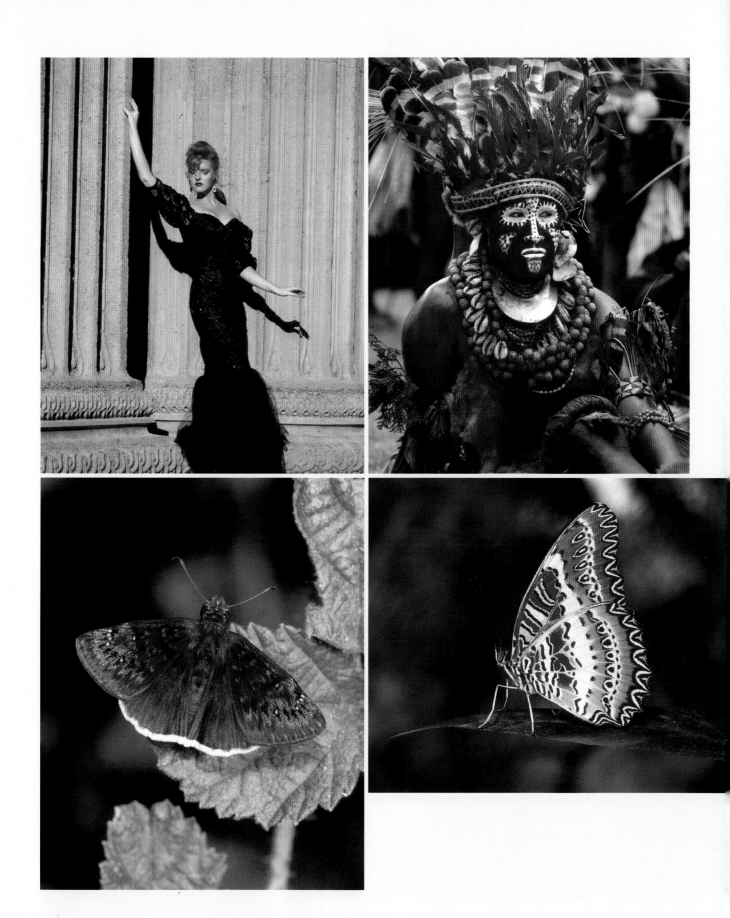

Shooting themes will increase the chance of marketing your work. When submitting your shots to magazine, calendar, and book publishers especially, a thematic group of pictures will make your proposal easier for them to use.

Notice the diversity of shooting techniques I used in this theme I call "sacred places." There are long, telephoto shots and expansive, wide-angle interiors. I included different types of weather conditions as well as a twilight time exposure, and there are detail shots plus one involving a man praying. I made sure there were both horizontal and vertical compositions to give a photo editor a wide range of possibilities in a layout. I always hope for a cover, so a few of the photos have room at the top of the frame for copy.

Keep these considerations in mind when you shoot. Think about the needs of photo buyers, and they will become long-term clients.

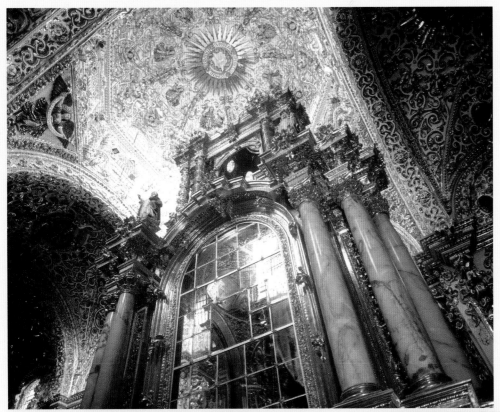

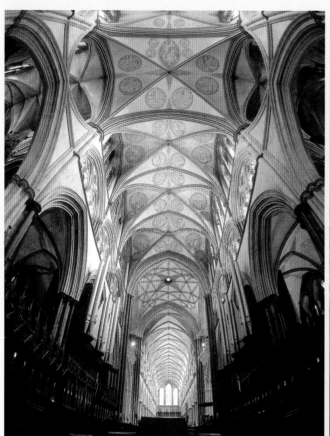

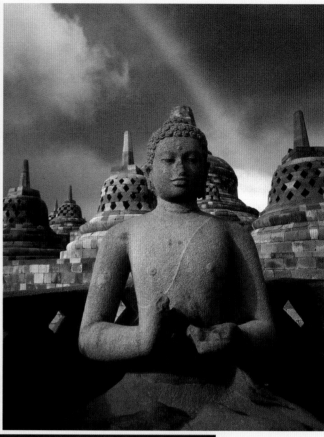

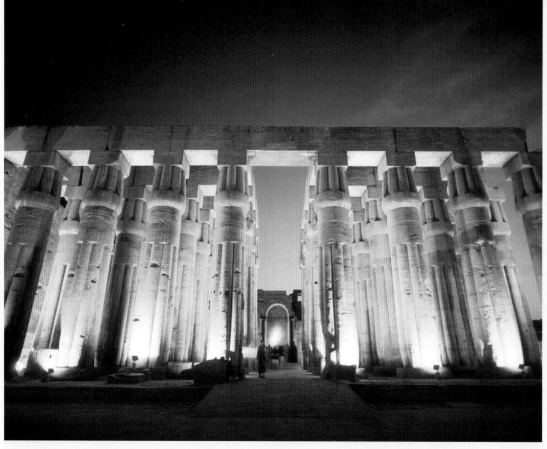

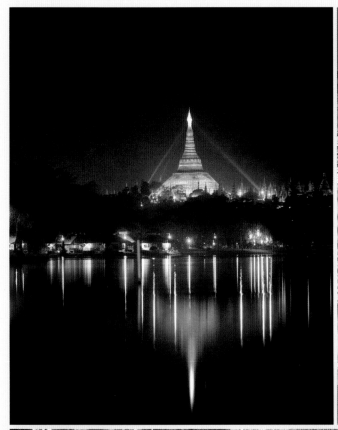

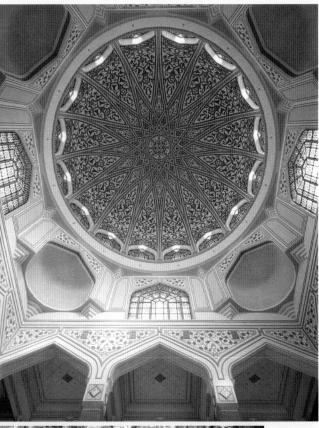

Trends change in photography. Techniques that were considered unacceptable just a few years ago may generate income for you today. An example of this is overexposed backgrounds. The loss in detail because the background was "blown out" used to be a grievous mistake. Now it's used in advertising and fashion work as well as in editorial layouts all the time. Wide-angle distortion is another example of a technique once considered too weird for mainstream photography but that is used quite often today.

Be flexible and willing to experiment with new ideas. Your clients will appreciate your creative efforts, and you can stay ahead of the competition. The photos shown here illustrate how I've incorporated movement blurs, overexposure, wide-angle distortion, double exposure, hand coloring as well as digital effects to offer clients new types of visuals with which they can capture the attention of the buying public.

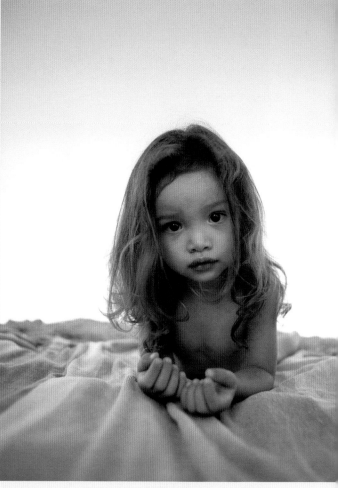

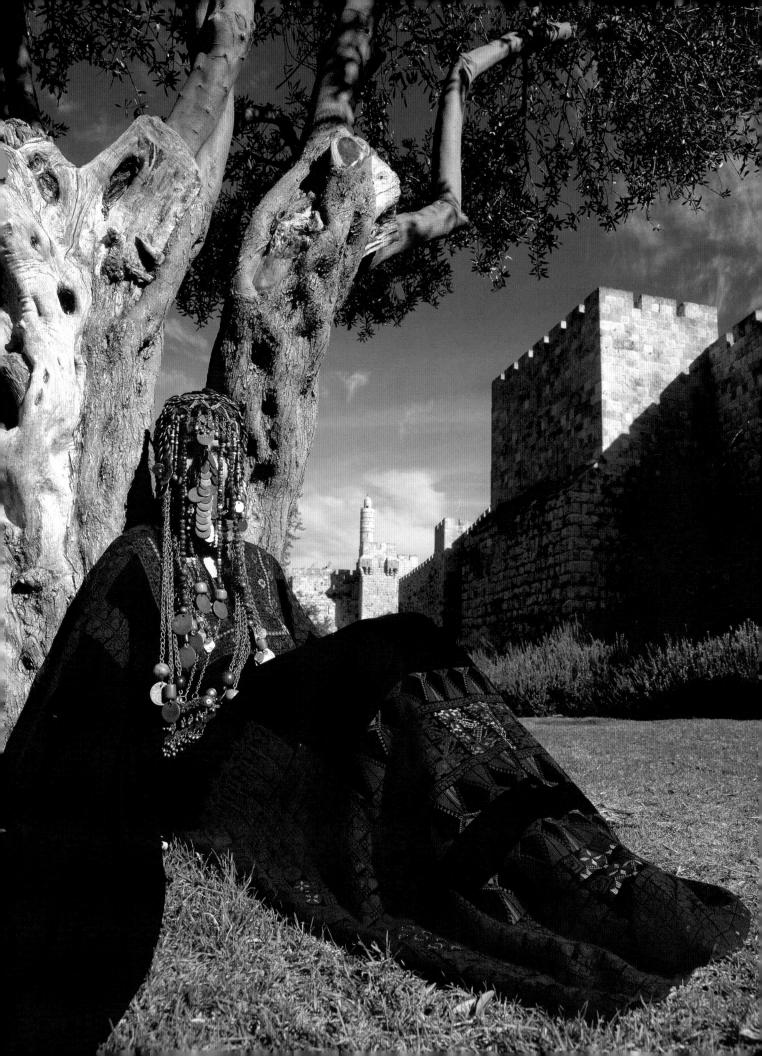

choosing a film format
digital vs. film

IT'S AN EXCITING TIME TO BE A PHOTOG-rapher. When it comes to camera equipment, we have a dizzying number of choices. The truth is that it can be quite confusing to decide which system to invest in. Thousands of dollars are at stake, and you don't want to make a mistake.

Camera systems are designed for specific purposes, so you first must determine what kind of photography you want to do. Only then can you know which format is right for you. For

PHOTO AT LEFT. Wide-angle lenses can lose a percentage of their drama when used on some digital cameras. This is one of the disadvantages of switching from film cameras to digital. Depending on the size of the chip, the effective angle of coverage is narrowed; thus, a 16mm ultrawide angle changes to a 20mm or 24mm.

Conversely, telephoto lenses are enhanced. A 300mm becomes a 400mm or 450mm when shooting digital. The newer chips have eliminated this problem; so when you buy a digital camera, make sure you inquire about the size of the chip to find out if the focal length of your lenses will be true.

In this shot of a Bedouin woman in Israel, I used the ultrawide 43mm lens on a Mamiya 7. I composed the shot to exaggerate the perspective. I wouldn't want to lose the drama of this kind of shot by shooting digital.

example, sports photography requires a system that's fast and mobile, while architecture photography must show crisp detail in every portion of the composition and must eliminate parallax (converging vertical lines). If you shoot a variety of subjects under a wide range of conditions, you will probably want to own (or rent) more than one type of camera.

DIGITAL CAMERAS VS. 35MM FILM CAMERAS

First let me address the question that everyone asks: Are digital cameras as good as film cameras in producing images that are sharp, rich in color, and offer good contrast? Will they make beautiful prints that are acceptable in the photographic marketplace?

The answer, in a word, is yes. But that's not the end of the discussion.

If you are primarily a 35mm shooter, the digital cameras available today are sensational. The high-end cameras from Canon, Fuji, and Nikon, for example, offer all the bells and whistles of their film models: interchangeable lenses, autofo-

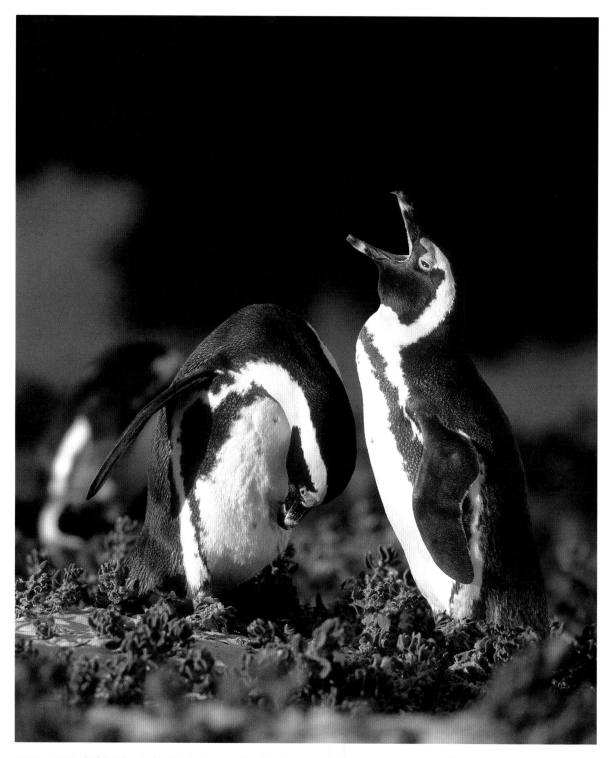

PHOTO ABOVE. An interchangeable film back on medium-format cameras comes in handy when things are happening very quickly. When the end of a roll is reached, you can snap on another fully loaded back without wasting the precious time it takes to thread a new roll of film into the first back. In the 35mm format, you must rewind the film and load a new roll. Critical seconds can be lost when something exciting is happening right in front of you. When purchasing a camera, there are many things to think about including speed, weight, mobility, automation, film size, and cost.

This shot of South African jackass penguins was taken with a Mamiya RZ 67 II, a 6cm × 7cm format camera.

PHOTO AT RIGHT. Large-format cameras have swing, tilt, and rise movements that change the relationship between the front and rear lenses with the film plane. The advantages to this system are many. Here the parallelism of the world's tallest buildings in Malaysia is corrected so they appear as we see them: parallel. Had they been photographed with a 35mm camera, the buildings would be leaning toward the center because the film plane would be oblique to the plane of the architecture.

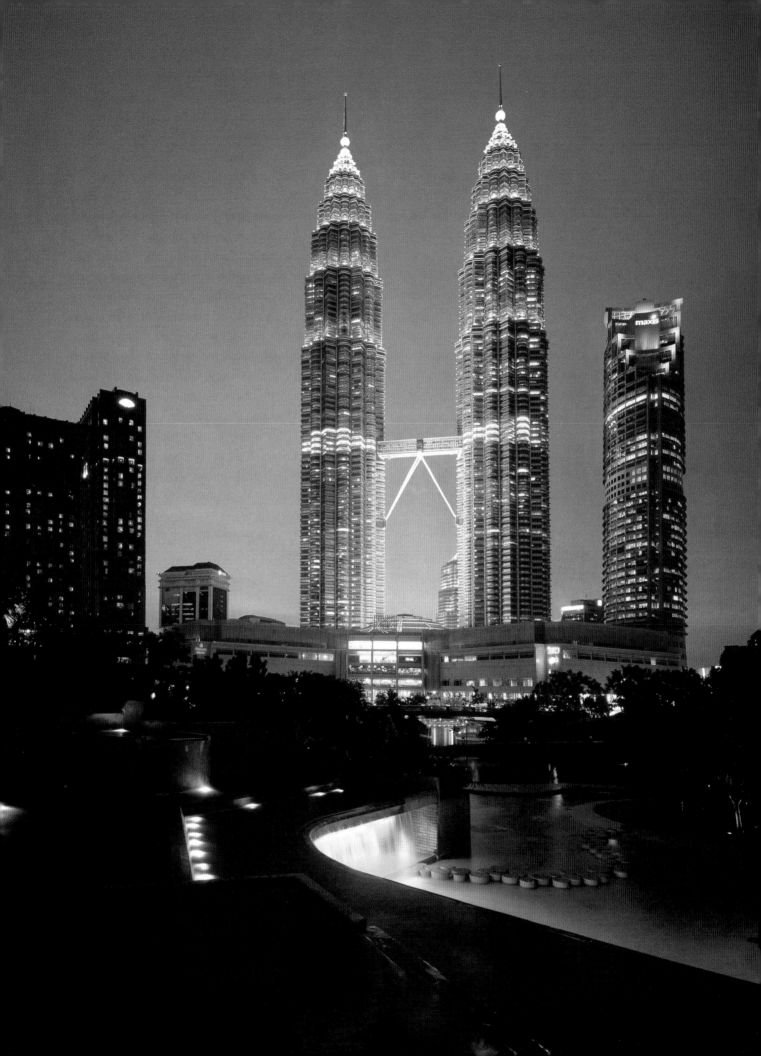

cus, autoexposure, image stabilization, various metering modes, motor drives, and so on. You can now take pictures that are more than 38MB in size. This is good enough to make enlargements as big as 30" × 40"!

If you compare the quality of a print made from a digital file with a print of the same size made from a 35mm slide that had been scanned with a high-resolution scanner, the digital file wins.

Let's look at the advantages of digital photography. It's a very convincing list.

1. The expense of purchasing and developing film is a thing of the past. This is a considerable savings. Over the course of a single year, you can spend thousands of dollars. Additionally, the sheer volume and weight of film you must carry on location is no longer an issue.

2. You can instantly monitor your shooting. You can edit and delete images; but more importantly, you know if you got the shot. No more fingernail biting until the film comes back from the lab.

3. You don't need a film scanner because all your images are already in digital format. You will spend no more time digitally cleaning each scan from dust or scratches, and there is no need to outlay a lot of money for the purchase of a high-resolution scanner.

4. When you are shooting an assignment and the client is supervising the shoot (or at least present in the studio or on location), he or she can instantly see the results and give an approval or suggest a change.

5. You can e-mail your photos to a client immediately—if you are connected to the Internet—from anywhere in the world. This means you can make an immediate sale to a magazine in New York even if you happen to be in Morocco or Bolivia.

6. Fluorescent lighting doesn't present a problem at all. With a film camera, an ugly green-blue cast is always produced when shooting with any kind of fluorescent fixture. Digital photography automatically corrects for this.

7. If the sophisticated built-in meter is fooled by backlit subjects, snow, or other tricky circumstances and some of your images are over- or underexposed, you can correct for this with the appropriate software and save important images from the trash bin.

8. There is no film grain.

9. You can change ISO settings at any point during shooting to deal with various light levels.

10. Airport security checks are no longer a serious hassle. X-rays won't affect digital files stored on the compact flash cards in your camera bag. They can turn their X-ray machine up to the max, and your blood pressure won't even budge. (However, the body scanners are electromagnetic wands and should not be placed close to your multi-gig flash cards. Instead, send the cards through the X-ray machine in a carry-on bag, thus bypassing the scanners.)

11. It is easy to make backup CDs of your best images. If all the originals are slides, much time is required to scan each image, clean and color correct them, then burn the CDs. If your photography begins as a digital file, burning two CDs takes only a few minutes, and you now have protected your best work.

What, then, are the disadvantages of using a digital camera? There are a few.

First, you can't give a slide show of original transparencies. Yes, digital files can be projected using an expensive unit to throw them up on a screen, but the resolution is not the same as an original color slide (although it's only a matter of time before projected digital files will compete with slides). If you output the digital files onto film at a service bureau, this will be costly and the

PHOTO AT RIGHT. When a client is supervising a photo shoot, a major advantage of using a digital camera is that he can determine whether or not the desired shot has been achieved. In addition, the image can instantly be e-mailed across town or around the world to a printing company for insertion into an advertisement or magazine. Subjects that are unpredictable and constantly changing—like puppies—give photographers much stress. It's nice to know when you have finally managed to get what the client wants by looking at the digital capture.

A digital camera offers instant gratification when shooting foreign models. You can show them on the camera's display what they look like; this always breaks the ice. Not only do they really get involved in helping you make great images, but all their friends and family now want to be photographed!

slides will essentially be second generation and therefore not impressively sharp. For the few clients that still require film for review, this can be a problem.

Second, I know of photographers who have lost an entire shoot due to digital glitches. For example, in one case a friend of mine had a hard drive that spontaneously decided to reformat itself, thus erasing all the downloaded images from the camera. In another case, a friend was shooting a clash between skinheads and a radical militant black group in Florida, and her digital camera had some kind of problem. The photos on the compact flash card were there one minute and gone the next. It is true that film cameras can malfunction as well; but if and when I make the change to a digital system, I will download each group of shots to two separate hard drives for insurance.

Even now, when I burn a CD of high-res

scans or digitally manipulated images, I make a backup copy and keep it at a different location than my office in case of a fire or some other calamity.

DIGITAL CAMERAS VS. MEDIUM- AND LARGE-FORMAT FILM CAMERAS

The digital technology for larger formats has also surpassed all expectations. The problem, however, is that digital equipment for medium and large format has two factors that require a close examination before purchase. First, the hardware is expensive. A digital back for a medium-format camera, for example, costs double or triple the original value of the camera. A 4×5 digital camera for a studio can cost tens of thousands of dollars.

The second problem is that the camera system must be tethered to a computer. The resolution of each image is so high that you need large hard drives to download the images for storage. If you take the equipment into the field, a laptop computer is required. This limits the mobility of your movements and the spontaneity of your shooting. For catalog work, such as fashion or products, this is less of a problem. In fact, many photographers who purchased this high-end gear say it pays for itself in just a few months. Their clients love the new technology because they can see instantly what they have, and the quality is phenomenal. But if you love wildlife, nature, and travel photography, it is quite impossible to deal with a laptop computer everywhere you go.

Soon, however, the prices for this equipment will come down, and we will be able to strap a small hard drive to our belt for the high-res downloads. When that happens, medium- and large-format shooters will have no excuse for not making the transition. Unless, of course, they are emotionally attached to film.

Speaking for myself, when medium-format digital technology is every bit as easy as using film, and the quality is equal to a $6cm \times 7cm$ transparency, I'm not sure what I'll do. I truly love film, but the advantages of shooting digital are compelling. It will be a hard choice.

DIGITAL BACKS

Most SLR medium-format cameras have interchangeable film backs. This allows you to change film in the middle of a roll and to quickly snap on another back with a fresh roll of film when things are happening quickly. A new generation of backs allows you to use a conventional camera with digital technology; instead of transparencies, your pictures turn into digital files.

The resolution of these digitized pictures is superb. You can make high-quality enlargements that are truly amazing. There are two problems, however, that have been an obstacle to many medium-format shooters taking the leap into this arena. First, they are very expensive. Of course, in a relatively short time, prices will come down. Second, you must deal with the same issue as with 4×5 digital cameras: The resolution of the digital files is very high and therefore the file sizes are large. This means that you need the large hard drive of a laptop computer into which you can download the pictures for storage. This is only workable in a studio. In the field it's just not practical.

CHOOSING A FILM FORMAT

There are basically four formats that professional photographers use to earn a living: 35mm, medium format (this includes 4.5cm × 6cm, or 645, 6cm × 6cm, 6cm × 7cm, 6cm × 8cm, and 6cm × 9cm), large format (4" × 5", 5" × 7", and 8" × 10"), and panorama (6cm × 12cm and 6cm × 17cm). The format or formats you choose depends on the subjects you shoot and the intended usage of the images.

35mm

Fast, quiet, compact, and auto-everything 35mm cameras are fun and easy to use because they don't get in the way of your concentration on a subject. All sports photographers and virtually all wildlife photographers (I'm an exception) use 35mm for several reasons. The cameras are indeed fast, offering high-speed motor drives, autoloading, and very fast lenses allowing you to shoot in low light with relatively fast shutter

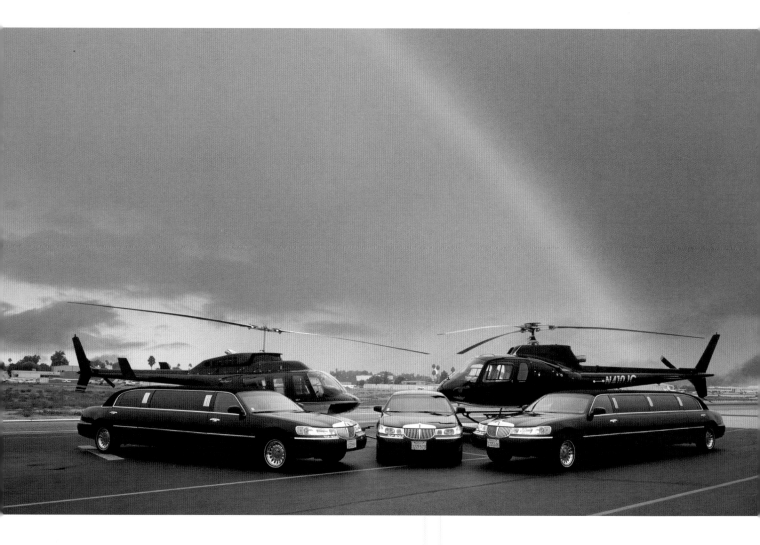

speeds. The autofocus capability alone is worth its weight in gold. Try keeping in focus a flying bird or a running football player with a manually focusing camera. It's almost impossible. It's more fun having a root canal!

Today's films are so sharp that a 35mm slide can be enlarged to huge proportions and be acceptable in the marketplace. It's true that the quality isn't comparable to the larger formats, but it is still quite good. More relevant, of course, is that if you were shooting a football game with a 6cm × 7cm camera, you'd miss most of the great plays, while the 35mm camera would be able to capture the action in sharp detail. Attempting to do the same thing with a 4 × 5 camera would be a joke.

If the final usage of a picture is going to be relatively small, such as a magazine cover, a full-page ad, a greeting card or calendar shot, or a CD cover, 35mm slides are more than adequate. With the superior printing technology we have now, printers can make your 35mm images look beautiful.

There are times when 35mm images will be used very large, but only when grain and softness aren't an issue. The trendy look in advertising where movement is used to elicit feelings about a product is an example. Models, wildlife, cars, or other subjects are essentially blurs due to long exposures. Thirty-five-millimeter photography is often used in this context.

Thirty-five-millimeter cameras can really be used for every type of photography, but some clients want a higher degree of resolution in the final reproduction. In these cases you will be required to shoot medium or large format.

Medium Format

The square area of a medium-format transparency is several times larger than that of 35mm,

therefore it will reproduce more sharply because it is being enlarged less times to fill the same space. Some clients prefer or even demand medium format over 35mm because they know that the final usage of the photograph will be large, such as a poster or a point-of-purchase display, and they require superior resolution. In some instances, though, even if the end usage will only be a magazine cover or full-page advertisement, a client wants a medium-format original to show the fine detail of a product, landscape, face, cityscape, or some other subject.

Medium format is used by most wedding and portrait photographers as well as aerial photographers, landscape and travel shooters, and fashion photographers; and sometimes it is used with product photography. Also, fine art photographers use this format to make high-quality gicleé prints. The print quality is so good today that when I make a digital print from a 6cm x 7cm transparency, to my eye it is virtually indistinguishable from a print made from a 4×5.

There is an important point to remember when using medium and large format. Depth of field is less in medium format when compared to 35mm, and large format offers even less depth of field than medium format. When comparing comparable lenses (say a normal lens), the same aperture (say f/8) will be physically larger in diameter in a medium-format lens than a 35mm lens; and it will be larger still in a 4×5 system. You compensate for this loss in depth of field by closing down the lens aperture. Although larger formats make better enlargements and may help sell your work, the price paid is the necessity to use smaller lens apertures with the predictable loss in light.

Large Format

Four by five and 8" × 10" cameras are pieces of equipment that are used slowly and deliberately, thus they can only be used for shooting subjects that don't move. With their ability to use swings, tilts, and rises, keystoning can be corrected (this is the apparent convergence of parallel lines, such as when buildings seem to lean into the top-center of the frame). Photographers who shoot architecture for a living must use large-format cameras because parallel lines are required for most professional jobs.

If you want to compete with the best landscape photographers in the world to make a living, use large-format cameras to give yourself an edge on the competition. The classic landscape technique, where the foreground is disproportionately large and dramatic, can be most effectively created using the tilt feature of a 4" × 5" or 8" × 10" field camera. Most serious black-and-white nature photographers also use large format.

Other applications where large-format equipment is used include high-end copy work, such as photographing a museum's collection of paintings, aerial photography, product photography, and certain types of studio portraiture.

Panorama Cameras

Any film format can be cropped to create a panorama image, but cameras designed specifically to make panoramas require no cropping and therefore have no loss in image area. The application for this format is limited. Once in a while you'll see a panoramic calendar, but most often the 6cm × 12cm or 6cm × 17cm transparencies are made into prints for fine art exhibits. If you want to be unique and like shooting landscapes or cityscapes, this film format may appeal to you. The cameras, however, are quite expensive.

building
your image

THE WAYS IN WHICH YOU CAN PRESENT yourself and your work in a professional manner have become tremendously varied as well as inexpensive. Right from your desk, you can carry on a slick promotional campaign without ever going to a printing company, a photo lab, or a marketing firm. If you are on a start-up budget, you can also avoid spending significant sums of money on postage and expensive portfolio binders.

Does this savings mean your presentation will be unimpressive? Not at all. In fact, with the technology available today, you can produce stunning print portfolios on art paper, make interactive CD-ROMs and DVDs with an unlimited number of bells and whistles, send digital catalogs of your images worldwide via e-mail, and design and produce direct mail pieces.

MAKING AN INEXPENSIVE PORTFOLIO

For under $500, and often for a lot less (a friend of mine recently bought a new Epson printer at a discount store for $88), you can purchase a high-resolution color printer. Quality printing paper that produces rich, saturated colors can be pur-

chased for as little as $0.20 per 8.5" × 11" sheet on the low end to about $1 per sheet for an ultra-exquisite high-gloss paper. Together with your computer, you can produce simple yet professional portfolios of your work.

The procedure is simple. First, scan the original slide, print, or negative with your own scanner or use the services of a service bureau. You don't need a high-res scan. My 8" × 10" prints are output from digital files that are no more than five megabytes. Then, design the page in Photoshop and print it on the paper of your choice. The fonts you use will be rendered sharply if you print at 1440dpi.

Below is a list of portfolio ideas that are easy to put together. I have used all of them at one time or another.

1. In Photoshop, center your photo on each 8.5" × 11" page of the portfolio. Place a thin black line around it; and if a description is appropriate, use an attractive font to add a brief caption to each photo. A drop shadow adds depth to the graphic design; I place it on the bottom of the image off to one side. Then, go to an office supply

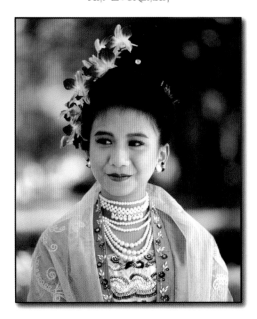

Young dancer, Yangon, Myanmar

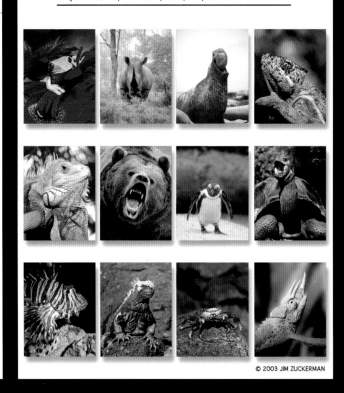

© 2003 JIM ZUCKERMAN

Here are two examples of how I've submitted print portfolios to clients using a desktop printer. When I design a page with only a single photo, I like my name at the top in an attractive font with a brief caption at the bottom. I outline the photo with a thin black line and create a drop shadow for a little depth.

One way of sending your work to a calendar company to propose a one-man calendar is to put twelve thumbnail images on a single sheet of paper. The print could be the typical 8.5" × 11" or larger. This gives a photo buyer at-a-glance suggestions. The theme shown here, "Faces Only Mothers Could Love," hasn't sold yet. Maybe I haven't sent it to anyone with a sense of humor yet.

store; for about $3, they will bind them with a plastic binding. A clear cover protects the first page and a black or white one protects the last. It is a very inexpensive way to put together a neat portfolio that can easily be carried with you or sent in the mail. When I travel domestically or internationally, I carry one of these in my camera bag because I never know what kind of contacts I can make.

I suggest that if you provide a description for each photo, don't give technical information such as camera used, f-stop, shutter speed, and film type. Photo buyers don't care. Also, don't give your photos cutsie titles like you see in art fairs. This makes you seem like a rank amateur.

2. Desktop prints can be put into precut mattes and carried in a briefcase for a professional presentation. The mattes frame each image and make it look more like a work of art. I prefer black or white matte boards with beveled edges, and I don't put a permanent label on the matte because I want to change prints to appeal to different clients.

3. A large selection of images (and accompanying music, if you like) can be burned onto a CD and sent as a compact portfolio. You can create artistic layouts for your images, create a digital slide show, or simply arrange them in catalog fashion. As you add or subtract photographs to tailor the portfolio to specific clients, you can make the changes in the file residing on your hard drive then burn a new CD. I make a custom CD

Jim Zuckerman

Badlands at 13,000. La Paz. Bolivia

This is the type of binding I use for certain types of portfolios. It is available at popular office supply stores and costs about $3. The binding is available in white or black, and there's a clear plastic protective cover on the front and an opaque back cover. It is very easy to carry with you or drop in the mail.

label and jewel box cover as a professional touch.

4. A portfolio can be comprised of a single 8.5" × 11" (or larger) print with a layout of several images on it when submitting ideas for a calendar, children's book, or greeting card line. It's an efficient way of putting several photos in front of a buyer without demanding more than a few moments of her time. For example, when I send a one-man calendar proposal to a publishing company, I lay out twelve photographs on a single print with a suggested title. Each image is relatively small, but I can always submit larger prints or a high-res digital file later should the buyer be interested.

5. When submitting to fine art buyers, you can use a Photoshop plug-in filter, Photographic Edges, to create unique borders on your portfolio prints for an artistic look.

6. Greeting cards can be produced with a desktop printer by simply printing on one-half sheet of card stock and folding it in half. For example, a 5" × 8" piece of stock can be folded to

4" × 5". You can create a box of ten or twelve cards and send it to clients or potential clients as a gift; but of course it doubles as a slick, mini portfolio. Christmas is an especially good time to do this, but any holiday could be used as a good excuse to send this gift/portfolio. For example, there's no reason why you can't promote yourself this way in celebration of the Fourth of July or, say, the vernal equinox. If you wanted to do this on a monthly basis as an aggressive campaign, you could do it in conjunction with the full moon.

SELECTING PORTFOLIO PHOTOGRAPHS

The selection process in putting together a portfolio is difficult. You are basically trying to second-guess a photo buyer to whom you may have never spoken. You may not know what kind of images they need, and in fact your potential client may not know what they are looking for until they see it. It's a very challenging endeavor, to say the least.

The first step in the process is trying to define the needs of the photo buyer to whom you are sending or showing a portfolio. This is only an educated guess; once you make the presentation, you will know more precisely what appeals to the company or individual who reviews your work. There are no hard-and-fast rules in making the selection, but I can offer some guidelines that will help you narrow your focus to target a particular market.

Fine Art

The art that people choose to hang on the walls of their home or office is usually selected because it is calming, beautiful, and very easy to live with. When submitting your work for consideration as a gallery exhibit, think about what is uplifting, pleasing to the eye, and soothing to the soul. Some people like subtle colors while others prefer supersaturated images that demand your attention when you enter a room. But everyone likes photographs that are pleasing rather than disturbing. For example, a shot of lions bringing down a cape buffalo wouldn't be appropriate as fine art. However, a regal male lion in his prime

blending into tall grass would be perfect.

Recently, I saw a gallery exhibit in Florida featuring exquisite photography presented in unique and innovative frames. The subject was Third World people, focusing largely on Ethiopia and New Guinea. While the subjects were intriguing indeed, the stark detail (medium format) of the impoverished people was not enticing as home decor. Only one print had sold over the course of a few weeks. Even though the presentation of the work was top notch, the subject matter wasn't the kind of art people want to look at every day.

When I choose images from my files for a fine art portfolio, I select primarily nature: a stately tree, a lovely pattern in sandstone, fields of flowers, white-on-white images done in winter, and moody weather looming above a landscape. Other work is appropriate, but I find people like to be surrounded by peaceful and inviting images.

Stock Photo Agency

Stock portfolios can number in the hundreds of images and are usually presented as slides or digital files. The photos should generally show a particular style or subject matter such as travel photography, business executives, photojournalism, or insects. If you are accepted into the agency, you can submit other types of images later. For an initial contact, however, your presentation should be focused.

Stock agencies will more readily accept you if you have images that fill a niche. In other words, if the company has an old or incomplete collection of baby animals, then you will have a better chance of being signed if your baby animal pictures can replace or expand the existing collection. Similarly, if your style of shooting people is innovative, different, and trendy, there is a good possibility you will be welcomed with open arms.

The sales that earn stock agencies the most money are photographs used for advertising. The end users of these images don't care whether or not the images are manipulated. This is true for pictures of wildlife as well as children, famous destinations, fashion models, hospital scenes, and every other subject. Advertisers sell a *concept*, and they are willing to use any type of image to convey their message. A few of the images in the portfolio examples have been manipulated in some way.

Advertising Agency

The first thing advertisers look for in a portfolio is: Will these images convey a message in just a few seconds? Will they make a consumer pause long enough to digest the concept? Creative directors are under tremendous pressure to come up with photographs that aggressively focus attention on their message.

What types of images can do this? Humor, color, eyes, fantasy getaways, and drama. These powerful ideas arrest a person's attention long enough for the ad to communicate a message. Choosing images for a presentation to an ad agency should rely solely on impact. Unique camera angles (ultrawide angle lenses used from a low angle), unexpected subjects (a painted face from Papua New Guinea), dramatic lighting (glowing eyes in the dark or whiteout conditions in nature), and the juxtaposition of unusual colors or tones (mixing black and white with color) are just some of the ideas that can help you land an assignment or sell a stock image.

I believe it's best to show large, dramatic prints in a slick presentation package. An 11" × 14" or 16" × 20" professionally matted print is all about hitting your client between the eyes. The way in which your photographs are presented is just as important as the images themselves because it says a lot about your professionalism, attention to detail, and work ethic.

Magazines

A magazine portfolio is different from the other types of presentations in that you should select images around a main theme. Almost all magazine layouts are thematic; that is, they focus on a particular subject, usually narrow in scope. For example, my photographs have been used to illustrate the following articles:

- John Wayne's kachina doll collection (I photographed them in the Cowboy Hall of Fame in Oklahoma)
- Monarch butterfly migration
- Havasu Falls in Arizona
- Cathedral ceilings of Europe
- A photo tour to Myanmar
- Going on your first African safari
- How to photograph butterflies
- Desert nudes

In submitting your work to a magazine company either in person or by mail, select images that illustrate a single idea. That idea could be fairly broad, such as "Spain's Costa del Sol," or it could be more narrow and focused solely on a particular town on Spain's sun coast. Or, if you were soliciting a food magazine, perhaps you could illustrate an article on the most romantic restaurants on the Costa del Sol. There are many angles to any location or subject.

Make sure that you give the photo editor a nice variety of horizontal and vertical shots. In a theme such as the Costa del Sol, you'll want wide-angle views of several famous towns plus close-up details of quaint courtyards, beautiful doorways, children playing, and twilight shots. A dramatic silhouette and sunset are good ideas, as are expansive pictures of the blue Mediterranean and a beautiful beach. It's always important to include a few choices for a possible cover. This means that there is enough room at the top of the vertical composition for the magazine's logo and on one side of the photo for copy that describes highlights of that month's issue.

Calendars/Posters/Greeting Cards

I have used several different types of portfolios in submitting work to paper companies. In the past, I sent transparencies—usually duplicates—but now publishers don't need to see slides. Some companies insist on inspecting the original film, but most of them are happy to review a CD or a print portfolio. I have submitted CDs many times, but I now feel that a collection of beautiful prints is more visually appealing.

For calendar publishers, I now submit a single printed sheet with twelve thumbnail photos on it suggesting a theme. Examples of some of the themes I've suggested are: wolves, dinosaurs (obviously digitally manipulated), frogs, India, Europe impressionism, Europe by night, owls, international dance, American Southwest, fantasy nudes, and African wildlife. All of the pictures I submit are horizontal, and all of them are composed in such a way that they can be cropped into a square. Most, but not all, calendars that fit into racks in retail stores are square. If you send images that are composed such that cropping them will destroy the beauty of the photo, you won't make the sale.

Greeting cards usually use only a single photograph, thus a theme of images isn't relevant. Choose images that are cliché, cute, humorous, colorful, and that represent a particular location in a beautiful way. City skylines are always salable, especially with a beautiful blue sky or shot at twilight. Other popular selling photos for cards are exquisite pictures of flowers, hand-colored landscapes, and cute interactions between children and puppies and kittens. Spend twenty minutes in any card shop and make a list of ideas to shoot. While you are there, write down the name and address of the companies producing the cards so you can create a database of potential clients.

DIRECT MAIL CAMPAIGN

A photography business is no different than any other business in that people must know you exist. That means you must advertise yourself. For those of you who are uncomfortable, insecure, or shy about showing your work to prospective buyers in person, a direct mail campaign is perfect. You can contact hundreds or thousands of people without having to make appointments and without having to sell yourself. A printed piece with samples of your best work does the selling.

The way in which direct mail promotions work is simple. First, decide who your market is. For example, you may want to send your mailing to magazine editors, photo and art galleries, music labels, paper companies, corporate art buy-

ers, and so on. Second, compile a list of names and addresses. This can be done through laborious research (going to a magazine stand and writing down the information from each magazine), or you can buy a mailing list. Mailing lists provide the names of thousands of potential buyers in very specific markets. The price typically ranges from $0.04 to $0.08 per name or $40 to $80 per thousand names. You can find companies that sell these lists in the Yellow Pages or on the Internet. Simply search for "mailing lists" and you will find many choices.

Next, design and print the direct mail piece. Postage is expensive, especially when you send out hundreds or thousands of pieces. Therefore, both the weight and style of the piece are very important. A single postcard is the least expensive. An oversized postcard costs more, while a printed piece placed inside an envelope increases the postage and printing fees significantly. I would suggest a postcard with one or more photos printed on one side with your name, address, e-mail, and Web site information on the reverse side along with the mailing label.

It is inefficient and too expensive to produce these pieces on your desktop printer. Direct mail pieces mailed in quantity must be manufactured at a local printing company. For color photography, you'll want a quote on 4C/1, which means four color on one side and black and white on the reverse.

A major part of the success of a direct mail campaign is analyzing the results. Keep track of how many calls or e-mails you receive, how many sales you make, and how much profit is generated from the entire endeavor. An average response to direct mail is 1 percent. A good response is 2 to 3 percent, and a sensational response is 5 percent.

If a mailing list you purchase returns a good response with several sales, you'll want to use that list again or purchase a parallel list in the future (for example, if you have a good response with photo galleries, you may want to try art galleries later). If a particular mailing isn't successful for you, there are two options. First, you can modify your direct mail piece, or second, you can buy

another type of mailing list. There is no absolute formula for success. Direct mail is a multi-billion-dollar business in the U.S., and highly paid firms who specialize in this are always experimenting with new ways to increase their return on investment.

PRESS RELEASES

One way to increase your exposure to the public is to send out press releases to local newspapers. Whenever you exhibit your work in a gallery, art fair, restaurant, or perhaps when your work will be sold at a charitable auction, send a notice to several local publications informing them of this. It costs you nothing and will keep your name in front of the public. Other types of professional endeavors also deserve notification, such as leading a photography tour or teaching a photo class at a local school. If you win a photo contest, donate prints to a charity event for fund-raising, open a photo studio, or develop a new business concept with your photography, local newspapers will probably publish at least a few paragraphs about it. They focus on local events and news, and they need to fill space every day or every week.

The press release is simply one or two sheets of paper that tell in straightforward language what you have done or will do. Newspaper articles are not exercises in creative writing, so don't embellish your release with superlatives and colorful language. "Just the facts, m'am." Entitle the piece "Press Release" and send it to as many newspapers and magazines published in your local and regional areas as you can. You may be surprised with the good PR you get—and it's free.

When I submit a portfolio on a CD, I print out a cover on my desktop printer. Using the CD label kit Stomper, I affix the cover onto the disk. It's difficult to know what a photo buyer is thinking, but I try to do everything I can to put the odds in my favor. A professional look is often just as important as the photography. These two examples of CD covers are only suggestions for designing your presentation.

When you select images for a fine art portfolio, it's important to keep in mind that people purchase art that is calming. Nature is the number one selling subject in fine art photography because natural beauty is peaceful and inviting to almost everyone. All of the images in this group of shots involve nature, although as you can see I've included an old car in snow, Indian models on a dune in the Thar Desert and Cambodian dancers surrounded by jungle at Angkor Wat. Nature is still the predominant element, but since different people have different tastes I try to offer a variety of choices. If an art gallery to whom I'm showing my work tells me they prefer to see no man-made objects, I simply return with a portfolio tailored to their needs.

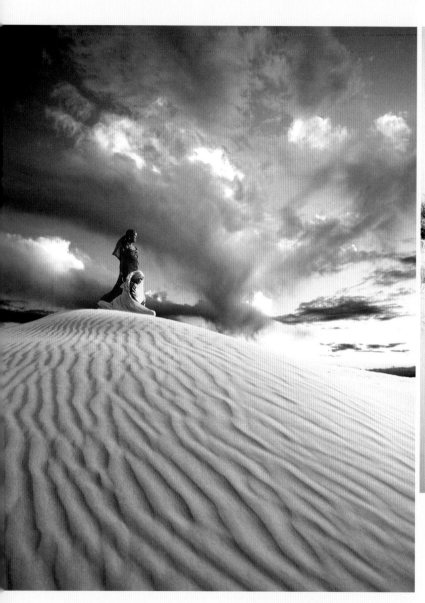

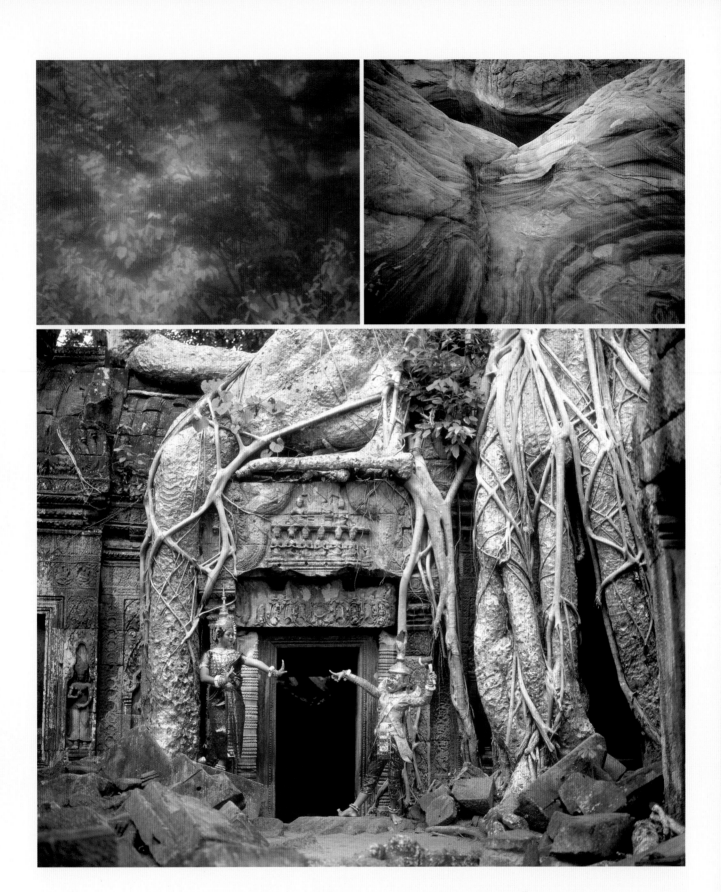

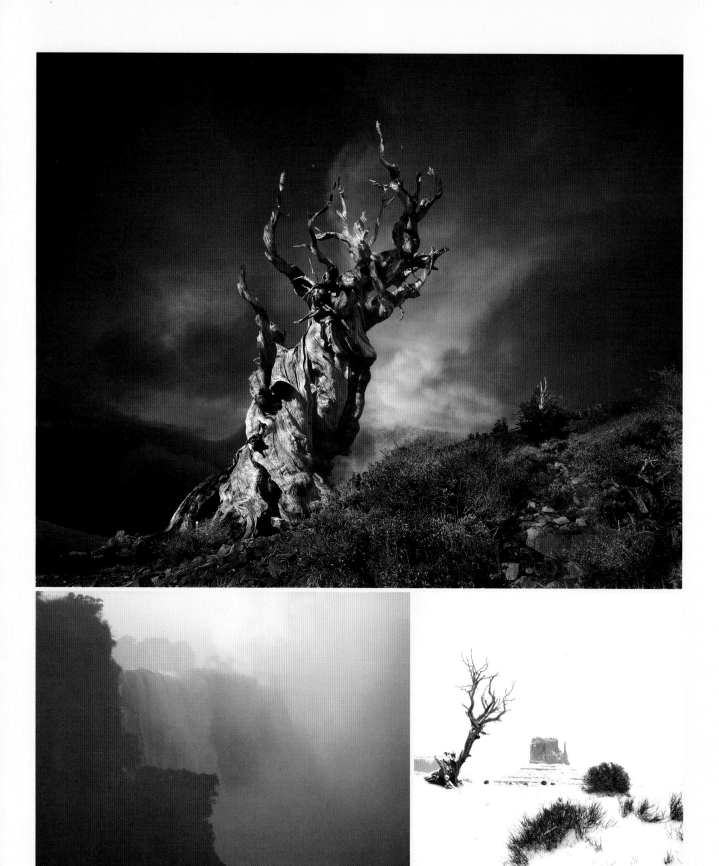

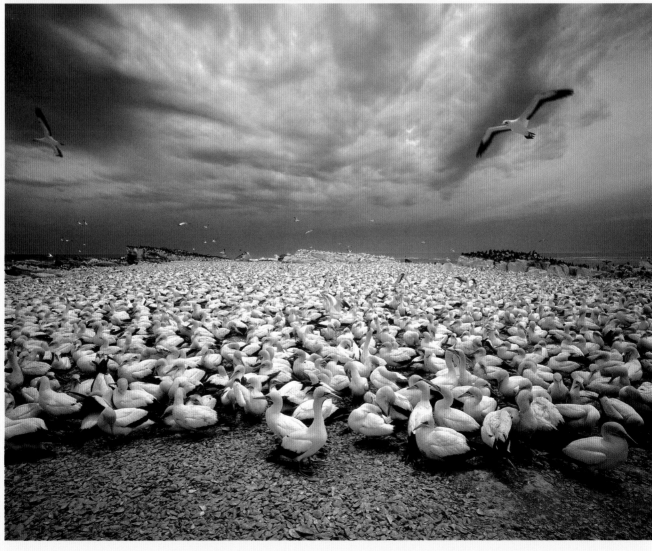

A stock photo agency submission usually consists of two to five hundred images. The photo editor who reviews your work wants to see slides (or digital files) of subjects that (1) fill gaps in the agency's collection, (2) display a unique style or technique, and/or (3) show a breadth of coverage of a particular aspect of photography. In addition, they want to feel that you have an enthusiasm to produce more outstanding images on a consistent basis. No one defines how many photos you must deliver on a monthly basis, but they don't want you to dump a couple hundred slides in their lap and expect to retire on the income without further submissions.

These images of children were shown to my stock agency when I first joined. I wanted them to know I could shoot children because they needed more pictures of kids. I selected photos from several countries and included spontaneous, humorous, and posed shots to illustrate the diversity of my shooting style. If you don't travel internationally but you love to photograph children, your collection of shots could have all been taken in your neighborhood. What matters is that your pictures are technically excellent, visually appealing, and can help the agency's clients sell their products and services.

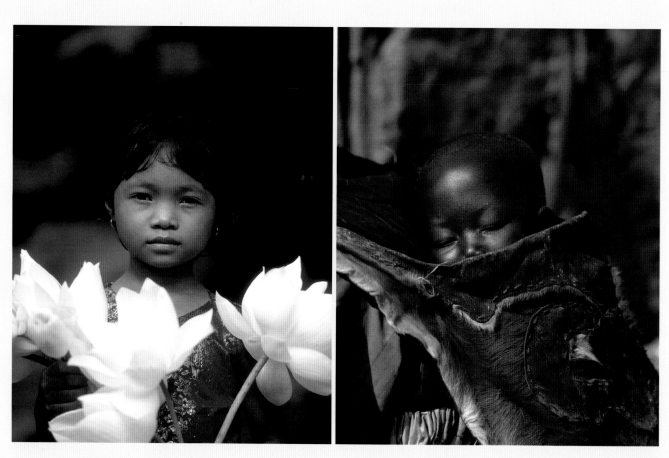

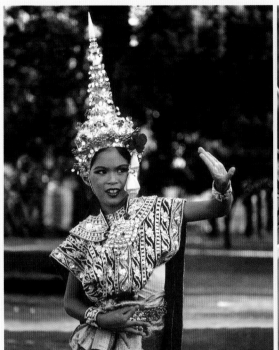

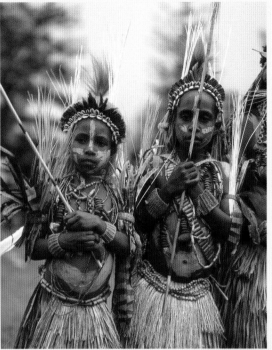

A typical wildlife portfolio to a stock photo agency could look like this one. I've included action, drama, a variety of seasons, intimacy, and cute and cuddly. The highest paying jobs are with advertising clients, and they often need shots that convey an emotion such as fear, strength, speed, power, tenderness, competition, and so on. If you have a collection of wildlife images that can express concepts such as these you should have no problem getting accepted by a stock photo agency. In this portfolio the hippos could represent competition while the mountain lion shot evokes a feeling of fear and aggression. The baby bobcat, on the other hand, is the cute and cuddly calendar or greeting card shot.

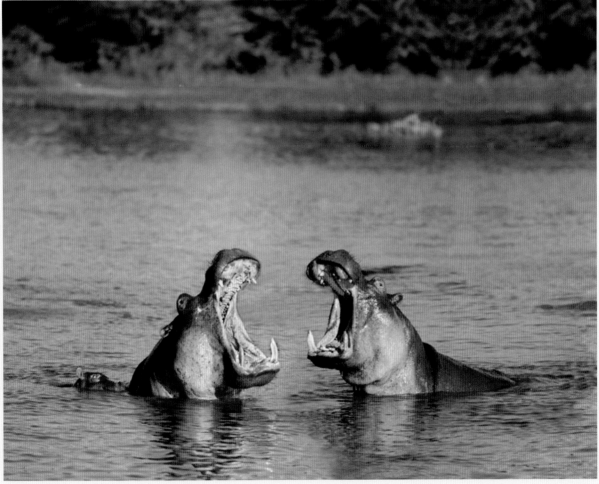

After I had been in my stock agency for a few years, I created a set of nature pictures taken with a scanning electron microscope. This is a special device that photographs very small subjects in great detail with tremendous depth of field. The images are always rendered in black and white, and the colors you see here were added in Photoshop. I submitted the portfolio to my agency as if it was my first contact with them. I showed a diversity of subjects from insects to pollen to blood cells, and they accepted the entire submission with an invitation to submit more. Once you are accepted into an agency based on a particular style or subject specialization, you can broaden the scope of your shooting to include other subjects. Scientific photos like these require detailed captions explaining what each image represents, the magnification, and the Latin name.

An advertising portfolio should consist of images that are strong enough to literally turn heads. Your images must appeal to people's emotions, their sense of humor, or their curiosity. Study the shots I've included here and think about the kinds of reactions you and others would have to them. Below is how I see them.

An advertising agency who reviews this kind of portfolio may not have an immediate use for any of these shots, but they can see my strengths and my vision. Perhaps in the future they'd purchase stock from me, but if they like the imagery I could land an assignment which pays more than stock.

Curiosity, shock value

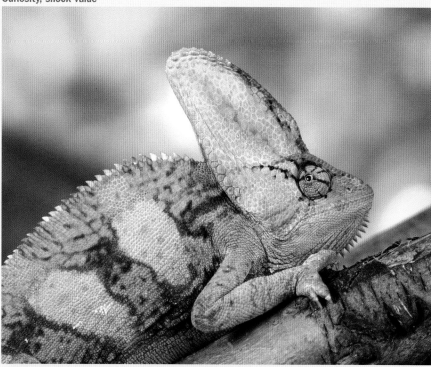

Humor

Shocking color and shocking subject to draw attention

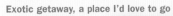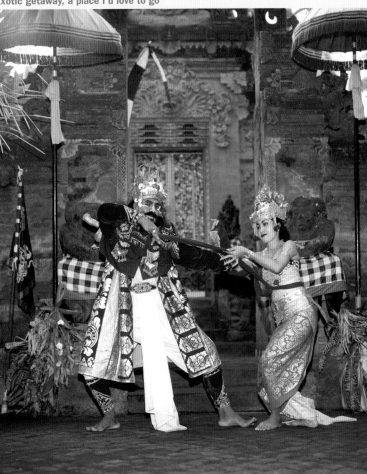
Exotic getaway, a place I'd love to go

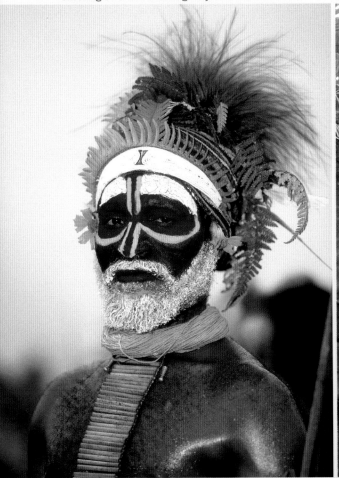

Shock value, curiosity and interest

Aggression, power, intense eyes, shock value

Cute, cuddly, lovable

Christmas without snow and cold—wow

Emotional and physical paradise

Unusual use of color, strength

A magazine portfolio should be thematic. Getting published in a magazine isn't difficult if you submit a group of pictures about which a narrowly focused article can be written. This collection of African birds is an example. Notice the variety of images I included: closeups, behavior, color, and both horizontal and vertical shots. There are also some images that could be used for the cover: vertical compositions with space for the magazine's logo.

If you have ambitions to be published in a particular magazine, contact them by phone and ask the editor what he or she might be looking for in upcoming issues. This isn't top secret information; they are constantly under pressure to find interesting article ideas and photos. If you can make their job easier both of you will benefit. Armed with this inside information, you'll know what kind of portfolio to submit.

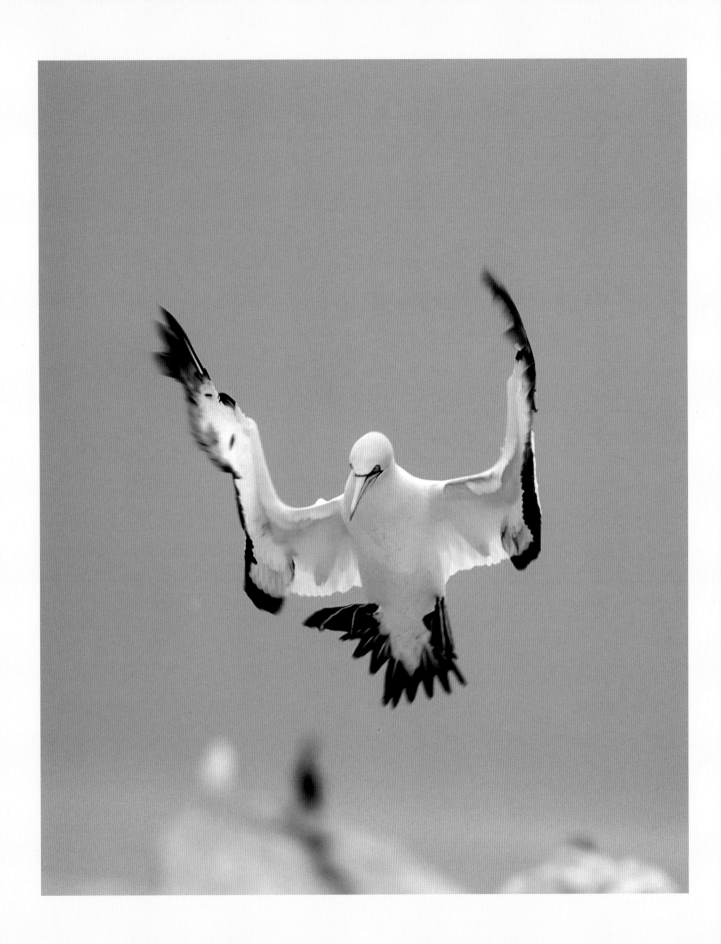

establishing yourself
on the internet

IF YOU DON'T HAVE A WEB SITE TODAY, people think you're not serious about being in business. It's that simple. Not having a Web site is like not having a telephone or a business card. It is an essential part of presenting yourself to the world as a professional photographer.

A Web site serves many purposes. It can be an online portfolio where your best work is showcased. It can explain the various services you offer, talk about how you approach assignments, list your photo credits, and provide a direct e-mail link. A detailed stock list of images can show potential clients at a glance the breadth of your work, and you can sell unframed and framed prints to the public. In fact, every time you hand out your business card, people are not just given contact information but an actual invitation to your virtual store. If their interest isn't publishing your work or hiring you for an assignment, they may very well be looking for home decor.

Web sites can also announce a newly scheduled exhibition, a seminar you're giving, a charitable event that is offering some of your photographs for fund-raising, or a photo tour you may be leading. Unlike printed brochures and direct mail pieces, Web sites can be changed as often as you want so the information is constantly up-to-date.

DESIGNING YOUR WEB SITE

You have a few options for creating a new Web site. The first option is to hire someone to design the site for you. You can easily find people who specialize in this: Search the Net for "Web site design;" call any university and ask for the computer science department; contact a local service bureau for references; e-mail Web sites you admire and ask for the e-mail address of the designer.

Depending on how elaborate you want to make your site (i.e., how many pages and how many bells and whistles), you can spend many thousands of dollars in design work or just a few hundred. I tend to like simplicity in Web site design for two reasons: It minimizes the cost in building it, and it focuses all the attention on the photographs, not the graphic design. A simple layout also eliminates confusion for first-time vis-

This is the home page for my Web site, www.jim-zuckerman.com. It was made using a template provided by www.better-photo.com. Note the placement of the buttons, the font used on the buttons, the color of the background, and the thin border around each image.

Compare my home page with that of my friend, who also established a Web site with betterphoto.com. At www.bobjensen photography.com, Bob used black as his background color and framed his image differently than mine. (He did this by photographing a picture frame, then, using Photoshop, he digitally inserted the photo within the frame. Finally, he uploaded the image to his site.) Bob opted to have his buttons on the upper left side of the page. Note also the counter just under the photo. This tells him and everyone else how many people have visited his site.

itors. Some Web sites have so much going on, that it's burdensome to plow through all the small text and myriad of buttons and boxes. On my site, everything is straightforward (visit www.jimzuckerman.com). I don't have music, which I think is extremely distracting; and nothing flashes, spins around, or otherwise diverts attention from my images.

If you want to save money and are willing to invest time in learning a new program, you can design your own site. I've used Dreamweaver, but a friend of mine likes Frontpage. Both programs take time to learn; but once you can navigate through one of them, you will be able to create any type of professional presentation for all to see.

USING A TEMPLATE WEB SITE

Another option to establish a Web presence is inexpensive and unbelievably easy to create. Betterphoto.com is a company that offers simple template Web designs. When you go to their Web site and click "Get your own Web site," you actually design your own site based on a questionnaire you fill out. You also choose a personal Web address, or domain name. Once you pay their low fee (at this writing it's $15 per month paid one year in advance, including the domain name), you choose the color of the background (white, black, or gray), the type of buttons you want, the placement of those buttons, the font, the type of border around each photo, and the number of columns (one, two, or three) for your thumbnails. You can also choose the photo or photos on your home page.

Within a couple of days, your site is ready to upload photos. For the $15 per month fee, you can display up to one thousand images. You have to resize each photo in Photoshop per instructions from Betterphoto.com. Then using their simple upload procedure, you create categories for your stock and place each photo in the appropriate folder.

My first Web site was created by a Web designer, but I set up my current site at Betterphoto.com. The current site serves as an online catalog for hundreds of my images.

ADVERTISING YOUR SITE

No one will know that you have a Web site unless you find a way to tell them. There are various ways to bring visitors to your site, and most successful Web businesses use as many techniques as they can.

Linking. An important way to publicize your site is to exchange links with other Web sites. You offer them a link on your site if they will be kind enough to put a link to your site on theirs.

Business cards. The URL for your Web site should appear on your business cards along with an e-mail address. This will bring many people to your site, especially when you talk about the photos enthusiastically. Hand out your cards to anyone interested in you, your photography, and anyone associated with the photographic industry.

Search engines. A search engine is a tool used to explore the Internet for specific information. When people search the Net for a product, service, or research data, some sites always come up in the first few choices. The owners of those Web sites have paid some kind of fee for that high visibility. This is called pay-for-performance and is a way to drive business to your site. Overture is a company that offers this service (their Web site URL is: www.overture.com/d/home/). You pay a small fee (like $0.15) for every person that checks out your Web site. The actual amount of money is based on a bidding system, where if someone using the same keywords as you (such as "fine art photography" or "travel photography") offers to pay $0.16 per hit, they supersede your position. When you realize the hierarchy has changed, you can then bid $0.17 and go back to being number one. Actually, the number two position is supposed to be the best one.

Get published. Every time your work is published, whether you write an article or you sell photos, ask the publisher to include your Web site address next to your photo credit.

Direct e-mail. You can pay a fee to e-mail information and photographs about your site to literally millions of people. This is the shotgun approach, because a large percentage of the recipients of this advertising won't be interested. But

Inside one of my categories at www.jimzuckerman.com, I elected to have three columns of pictures. Also, I didn't give a title or description to each picture, only a number. I wanted a very clean, uncluttered look.

On one of Bob's interior pages, his frame borders are different than mine, and he identified each photograph and provided a location.

My original Web site was custom designed by a friend of mine, Steve Shelden. It was originally designed only as a showcase for my work, not as a commercial Web site that could generate income. I subsequently modified it to include many things for sale.

it's simply a numbers game, and this inexpensive method will bring a certain amount of activity on your site. On any search engine, type in "direct e-mail" and you'll find many companies that offer this service.

Maintain a mailing list. Any person that contacts you regarding your photography, for any reason, should be on a mailing list. On your Web site, you should have a place for visitors to add their names to your site. Use this list to promote yourself. If you are traveling to Europe, for example, let people know your itinerary and the duration of the trip. Tell them you are accepting assignment work and would be happy to talk to them about their needs. Inform people on your mailing list about an exhibition, a new body of work just completed, a new area of specialty you've begun, and anything else that may generate income.

Keep track of your hits. Web hosting companies offer a service that allows you to track the number of visits, or hits, your site receives. Data is also provided that tells you where the hits are coming from, the time of day, length of stay, and many other useful bits of information that may help you target your market. This research information costs only a few dollars per month, but it is well worth the insight you get into who is seeing your work.

PRINTS FOR SALE

Many photographers offer their prints for sale on the Web. This can be an important source of income. With the phenomenal desktop printers available today, you can minimize the cost of each print by producing it yourself. This increases your profits as well as allows you to maintain complete control over the printing process. And with the new archival inks, you can be confident that fading is no longer a concern (however, keep all prints away from direct sunlight).

The choice of printing papers, matting, and framing is a personal one. You will have to test the market to find out the most popular variations for your work. For my own work, I prefer two types of prints. I like a matte digital output on Somerset paper, which is a soft white, slightly textured paper. Somerset paper is available for use with desktop prints as well as commercial Iris printers. It is elegant and indicative of fine art.

I also like the Light Jet prints, which are ultrasaturated, brilliant prints that hit you between the eyes with drama. Companies that make Light Jet prints can be found on the Internet. I use Midwest Photo Company [(800) 228-7208]. They made a Light Jet print for me that was 40" × 60". The clients were so blown away by how amazing the print was that for fifteen minutes they kept me on the phone with praise and thanks.

When I display prints for sale on my Web site, I do so showing them framed. Although people can purchase them unframed, a clean, elegant frame adds perceived value to an image even if the buyer wants to use another type of frame.

Pricing is always a difficult subject. You can experiment with various formulas and see what works for you. Since you can print your photographs from a desktop printer, affordable prices can be offered on your site. Or, you can target a high-end clientele with signed, limited edition prints and ask more money for your work. Both strategies have worked for photographers. Search the Web by typing in "photography prints for sale," and do a little survey on print prices vs. print sizes. See how other photographers are presenting their work.

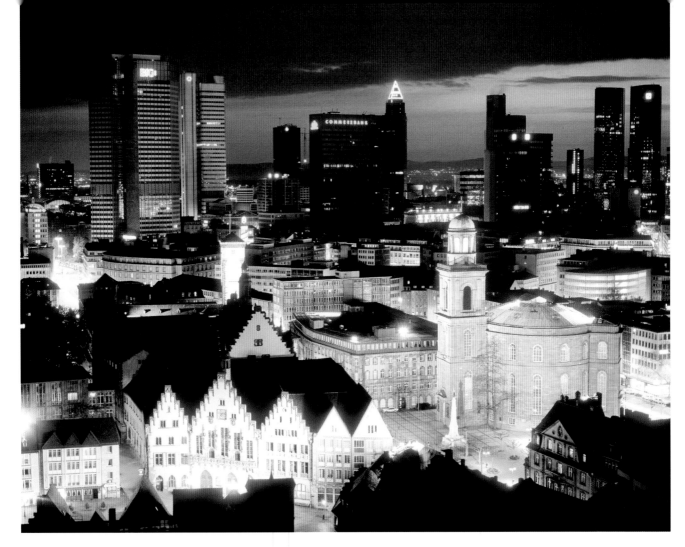

TRANSMITTING YOUR IMAGES

One of the wonderful advantages of having a Web site is the ability to send photographs across town or around the world. Even though Internet connections are much faster than in years past, we still send only low-resolution photographs when using e-mail. But what happens if a publication is on a critical deadline and they need a cover shot right now, not tomorrow? A low-resolution image via e-mail won't have enough information for superior reproduction for cover art, a full-page ad, or a calendar shot.

I had a situation where I had sent a CD with high-resolution images to a photo magazine published in Mumbai, India. They e-mailed me just before they went to press requesting a shot they'd seen on my Web site for the cover. I hadn't included it on the CD, and there wasn't time to send it overnight to India; besides, transportation time with FedEx, UPS, or DHL would take three days.

Instead, in Photoshop I resized the image they wanted according to their specifications:

8.5" × 11" at 300 dpi. This produced a 24.1MB file. I saved the picture as a JPEG, which reduced the size to only 1.6MB. [When opened, the photograph indicated 24.1MB; but when I clicked on the icon of the photo and clicked Command 'I' (Control 'I' on a PC), the true file size of 1.6MB is revealed.]

I uploaded the image to my Web site and gave it a unique address: www.jimzuckerman/redeyefrog. I then e-mailed the publisher in Mumbai this address, and they downloaded the file. The entire process took about thirty minutes from the time they made the request until they had the file in their computer. When they sent me the magazine three weeks later, the cover shot was very sharp and the colors were perfect. There was no degradation in image quality at all. It was as if they had been sent the original 6cm × 7cm transparency and made the color separations directly from the original!

A client selected this image because I was able to meet a deadline by e-mailing a selection of low-resolution images. I recommended two methods of printing large photographs: an Iris print on Somerset art paper, which offers a soft, watercolor look, or the ultrasaturated Light Jet print. They chose the latter in a 40" x 60" size. I charged $1,000 for the job.

selling your work
at art shows

OUTDOOR ART SHOWS OFFER YOU A venue to sell your work directly to the public. You don't have to get past a photo editor, gallery owner, creative director at an advertising agency, or stock photo agency. You can be a novice or an experienced photographer of many years to exhibit at an art fair. You can be technically clueless with an artist's eye or a sophisticated black and white printer. It doesn't matter. The only thing that's relevant is: Will the public buy your photos?

Some art shows are juried. This means that a group of people associated with the company promoting the fair judges a few of your images to determine whether or not they will rent a space to you. This is actually an advantage because it means the artists exhibiting at this particular event are quite good, and this in turn usually attracts a lot of people. Most art fairs are not juried, so anyone can show their work as long as they pay the fee for a 10' × 10' or 10' × 20' space. The typical fee is $225 to $275 for a weekend, but this can vary depending on the region of the country. This includes only the space; you provide the materials used to display the photography.

GETTING STARTED:
LOCATING ART SHOW EVENTS

The first step is finding out where and when art shows take place. There are a number of publications that give all the details you need to know, including dates, fees, and the phone numbers of contacts if you want to reserve a space. Some of these magazines are regional while others cover the entire U.S. Below is a list of a few of them.

CRAFTMASTER NEWS

P.O. Box 39429

Downey, CA 90239

(562) 869-5882

Western States

ART & CRAFT SHOW YELLOW PAGES

P.O. Box 484

Rhinebeck, NY 12572

(888) 918-1313

Connecticut, Massachusetts, New Jersey, New York, Pennsylvania, and Vermont

Epson printers offer remarkable quality and speed and can print photographs on many kinds of paper. The cost has dropped significantly, which means you can now bypass photo labs and produce all the prints yourself. In ink and paper, the cost for a 20" × 24" is about $10. If you factor in the savings in time and energy in taking your work to a lab, waiting a week, and then bringing it home—if the print is correct—these printers are a bargain.

WHERE THE SHOWS ARE

P.O. Box 453

Edgewater, FL 33132

(904) 428-0173

Florida edition and Mid Atlantic edition

SAC

P.O. Box 159

Bogalusa, LA 70429

(800) 825-3722

National

Some of these publications tell you which shows are considered better than others in terms of actual sales. Some photographers who are not sure they want to pursue this type of marketing go to art shows and talk to other photographers. Many of the people who are already showing their work are willing to provide helpful information.

CREATING AN ATTRACTIVE BOOTH

I have seen photographers at art shows display their photos on nothing more than collapsible tables. This is cheap and doesn't require a large vehicle to transport more professional materials, but there are two disadvantages. First, it doesn't look like you're really in business. It's amateurish. Second, the photographs are exposed to the weather. Many hours of direct sunlight are terrible for photographs, whether they are printed in the darkroom or made on an ink jet printer. And if a little rain dampens an afternoon, you don't have any protection.

All serious exhibitors purchase one or two 10' × 10' canopies. Costco sells them for about $250. For one person they are a bit heavy (yet still manageable if you don't have a bad back), but two people can easily carry it and set it up at a show. From a folded position, it cleverly expands and raises up into the full 10' × 10' square dimension with about 7' clearance from the ground to the overhead aluminum supports. The translucent white fabric of the canopy provides soft, even illumination on your photography and protects the prints from the harsh, midday sun.

The next thing you need are panels on which you can hang matted or framed prints. You can certainly make them; but by the time you've invested your time and purchased material to make them look professional, I'm not sure you've gained much. Most photographers who have turned this type of endeavor into a business use Pro Panels. This company produces display materials specifically for portability. They are designed to be attractive and sturdy. You can visit their Web site at www.propanels.com to see what they offer, or you can call them at (214) 350-5765.

Pro Panels offers a number of colors (most photographers choose a medium or dark gray fabric) as well as booth configurations. All these options are clearly shown on their Web site. The total cost to set up a 10' × 10' booth, including all the necessary panels plus the canopy, will be approximately $1,300. There are a number of options and accessories to consider, but this is a rough price to give you an idea. If you are on a tight budget, this can be a daunting sum. Every enterprise, however, requires investment. As businesses go, this is a very small one. And the benefits are considerable if your work is accepted by the public.

You should also have a small table and two folding chairs in your booth for a customer to sit down and write a check or for you to accept a credit card. On the table you should have an open guest book. Guests interested in your work should be invited to sign it and add their address and e-mail information. This gives you a mailing list. When you next have a show in the area, send them a notice. Tell them about your new work and that you'll look forward to seeing them again.

MATTING AND FRAMING

Some photographers exhibit their work in mattes only, while other people offer framed pieces exclusively. Most, however, have both matted photos as well as framed. This gives the public a choice. Customers who want to spend less money and frame the prints themselves will purchase the matted pieces. Those who want something they can take home and hang on the wall without further expenditure of time and money will buy the

You will see many types of booths at art shows. The panels in the photo on the left were homemade, while the gray panels in the photo below were purchased from Pro Panels. The canopy protects both you and the photos from the sun; but depending on where you are allowed to set up, the sun may become a problem during the day. Try to use the shadow of a building or tree to block harsh midday sun from your prints.

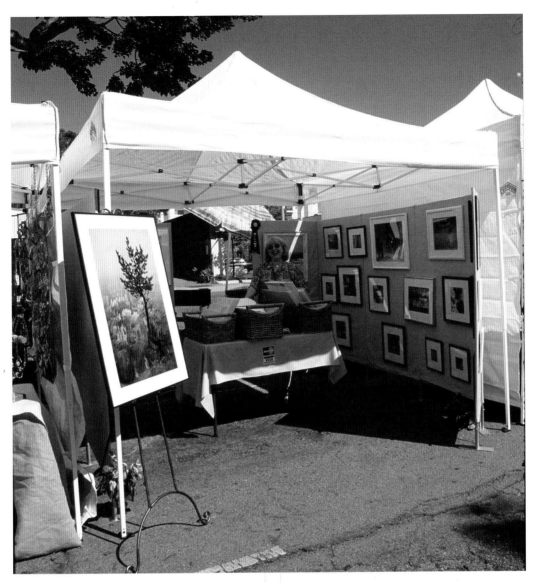

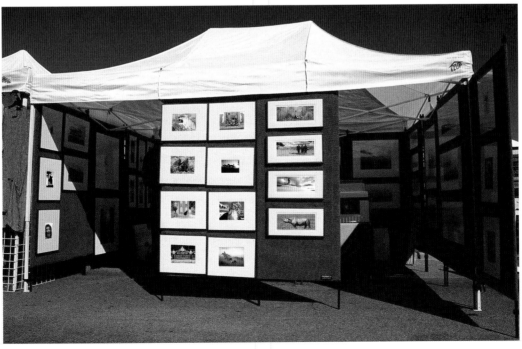

This shrink-wrap machine is easy to use and puts a taut piece of plastic around a matted print. It takes about two minutes to seal each photo this way. Many exhibitors prefer the plastic bags available from Impact Images because it takes less time to insert the prints into the plastic bags and there's no initial outlay of capital to buy the machine.

framed prints.

It is obviously important to keep your expenses to a minimum to increase your profits. You must find wholesale sources for your supplies. Some photographers cut their own mattes to reduce costs to a bare minimum, but I opened an account with a company offering wholesale prices for bulk matte purchases. In my opinion, the time saved is worth the extra dollar or two it costs to have someone else do the work.

The wholesale supplier I use for mattes is Dot Line Corp., 9420 Eton Avenue, Chatsworth, California 91311 [(800) 700-9997]. To set up an account you'll need a resale number that proves you're really in business; this will also save you applicable state sales tax. They have a dizzying number of choices of acid-free colored matte boards and will cut standard or custom sizes. I prefer white or black mattes for my work. I believe most customers do, too.

The quickest and easiest way to affix a photo in a cut matte is to use a single piece of strong masking on the top edge of the print. The top matte will keep the entire print flat when it's taped or glued to the back of the matte. In the past I've used a special mounting glue on the back of the print to flatten it on the rear matte board, but the process often turns into a sticky mess.

When the process is complete, sign the matte board just under the photograph. Use a pencil for white matte and a gold pen for black.

Once the print is matted, you will want to protect it from getting dirty. There are two choices. Inexpensive plastic bags that seal with a pregummed strip are available from Impact Images, 4919 Windplay Drive, Eldorado Hills, California 95762 [(800) 233-2630]. It takes only a few seconds to place the matted print into the clear, plastic bag. Another option is to shrink-wrap each photograph. This requires the purchase of a machine for about $250, and the process takes a bit longer than using the plastic bags. The difference in appearance is that the shrink-wrap process puts a taut plastic covering over each matted piece while the plastic bag is loosely fit.

There are various ways photographers display their matted prints, from fabric-lined baskets, rough-cut wooden crates, and commercially available print bins. Make sure the prints are protected and that it is easy for customers to quickly thumb through the selections. Go to an art fair and see what other shooters are using.

When you frame your work, keeping costs down is even more important because frames can get very expensive. Custom framing is an art form; a beautiful frame can present a photograph with elegance. But if your costs are too high, you may be forced to price your work beyond the acceptability of many potential customers.

Therefore, most photographers who exhibit in art shows use simple, inexpensive but attractive frames purchased at wholesale prices. A supplier I've used who has excellent prices is: Wholesale Art and Frame, Ltd., 1425 Thirtieth Street, Number 4, San Diego, California 92154 [(877) 200-0345]. You can check out their Web site for their other locations in the U.S. and see examples of their frames online: www.whslartframe.com.

PRINTING YOUR WORK

In my opinion, color printing in the darkroom is a thing of the past. I know that there are still some photographers who love darkroom work and are masters at printing their slides or negatives using conventional means. Today, however, desktop printers are simply fantastic at producing digital prints. The results are beautiful, sharp, and saturated; and you can print on many kinds of art paper. The inks available today are archival, so you can assure your customers that they won't fade for many, many decades. In addition, the ability to tweak the original color balance, contrast, saturation, and tonality is infinite, allowing you to make a good picture even better.

I recommend the printers made by Epson. They are fast, efficient, and quiet; and the prints are much cheaper than those done in a photo lab. The Epson inks are superior both in color and longevity. Not only are the colors stunning, but your black-and-white images can now be printed with brilliant tonality and richness.

Epson is always coming out with new models, but three new printers released in late summer 2002 are the 2200, 7600, and 9600. The 2200 produces up to a 13" × 19" print; the 7600 will print on paper 24" wide and as long as you want; and the 9600 will print on 44" wide paper with the length also determined by your file dimensions.

The printer that I recommend for art show exhibitions is the 7600 model. You can print large 24" × 36" prints (this is the largest print proportional to 35mm film format that can be made on this printer) as well as smaller prints. You have a myriad of choices of paper that the printer can handle, allowing you to artistically customize your work. The money and time you save by producing your own large prints will more than pay for the investment in this machine. However, if you want to invest slowly without risking a lot of capital, you could consider the 2200. Smaller and less expensive prints will make your work more accessible to people who appreciate photography but are on a limited budget, yet the quality will still be evident in the prints.

PRICING

The art of pricing your work is a never-ending quandary for photographers. Should you price prints high for an upscale market? This implies your work has value, but at the same time many people won't spend hundreds of dollars for a framed photograph. You may make a good profit from each sale, but the number of sales you can expect will be less. If the price is too low, however, some potential customers may think your work doesn't have value. To serious collectors of fine art photography, these considerations are important. To someone who simply wants to decorate a bedroom or an office, it's probably irrelevant.

In certain areas of the country where the cost of living is higher, such as southern California, south Florida, or certain parts of New England, higher prices can be asked. In other regions, you have to be aware of the economic conditions of your clientele and adjust your pricing accordingly.

I have spoken to many art show exhibitors to get a sense of what they charge for their work. It varies tremendously, of course, depending on the quality of the images, the presentation, and the area of the country. One lady I know sells unframed pictures of Italy in white mattes. Her work is very "snapshottish," and she prices 8" × 10"s at $30. Another photographer who does very sophisticated hand coloring on 16" × 20" framed black-and-white prints (made from 4" × 5" negatives) sells each piece for $750. His work is truly exquisite, and he'll sell several pieces at each show.

The average price ranges of prints I've itemized for you below should get you started in pricing your work. The best way for you to get a real feel for prices is to attend some art shows in your

selling his work at art shows has done very well with three prints in a series under one frame. He sells three 4" × 6" or 5" × 7" prints in a custom three-window matte and simple frame for $90.

GETTING PAID

When customers give you personal checks, you should always write down their name, address, phone number, and driver's license number in case there is a problem with the check. Even if someone seems really nice, make it a habit to protect yourself. When people pay with cash, you can check the legitimacy of large bills with a special marker pen available at most stationery stores. A nice-looking $100 bill that turns out to be counterfeit will definitely hurt.

Credit cards are a necessity if you don't want to lose business. Many people don't carry a lot of cash with them, and checkbooks are often forgotten at home. Frequently a customer had no intention of buying something until he saw your work, and the only means of payment he has is a credit card. Speak to your bank to find out how to set up a service account that allows you to accept at least three major cards: Visa, MasterCard, and American Express. Always get a verification number with each transaction. If your bank doesn't offer this type of business, they will know whom to call. You can also do a search on the Internet for banks that offer commercial credit card accounts.

EXPECTATIONS OF PROFIT

The art show business is a fickle one. Some weekends can be fantastic, where a photographer whose work is excellent can make several thousand dollars. In other instances, a show that is supposed to be good turns out to be a waste of time or, worse, a financial loss. You have to look at the business over the course of a year. If you have one bad weekend, don't give up.

Recently a friend of mine showed her photos in an art show in Malibu, California, the home to many movie stars and other wealthy people. She had heard it was a good show, but on Sunday

area and see what other photographers are asking. Determine if you feel the work warrants the price, and try to find out if the photographer consistently has sales.

Remember that these are average prices. Some photographers price their work higher.

	MATTED ONLY	MATTED AND FRAMED
8 x 10	$25 to $65	$40 to $100
11 x 14	$45 to $95	$85 to $150
16 x 20	$110 to $225	$145 to $295
20 x 24	$175 to $295	$195 to $425

I've seen some very clever marketing techniques besides standard size framed pieces. For example, panorama prints have become popular. A friend of mine who retired and then started

All types of photography are sold at art shows. You see black and white, digitally manipulated work, travel, landscape, flowers, wildlife, infrared, hand-colored prints, and more. The photos on pages 90 and 91 are a perfect example of the variety of art show images. Keep records of how many prints you sell of each photo. If some images don't sell well, replace them with others. This is not a science; it's an art. Trial and error helps us fine-tune our marketing efforts.

night she called and said it was a disaster. She didn't make back her $250 fee for the space. A month earlier she showed her work in a small park in a middle-class area of Los Angeles and made $1,500 in a weekend.

Another friend of mine who has been exhibiting his work in art shows for five years averages between $2,300 and $4,500 per show. His best show was in Scottsdale, Arizona.

Every time you present your work in an art show, you will gather more information about how to improve the way in which you do business. It's a constant learning experience. There are people who make in excess of $100,000 per year doing this, but they got it down to a science over many years.

If your work is attractive, if it's priced well and presented professionally, it will sell.

stock photo
agencies

A STOCK PHOTO AGENCY IS A COMPANY that functions as a rental library for photographs. It literally has hundreds of file cabinets with millions of slides categorized by subject and/or location. When a client needs an image for a magazine cover, a billboard, a textbook, a trade show display, packaging design, or any other purpose, the agency rents the usage of one or more images selected by the client. With the photographer's approval, they can also sell all rights to a photo should a client wish to own the image outright.

Some photographers only feel comfortable on a work-for-hire basis. You get an assignment, you do the work, and you get paid. Stock photography is very different. The gratification, i.e., the payment for your work, may be delayed months or even years. A picture that you take today may not sell until next year or even three years from now. Or, it may never sell. On the other hand, it could sell twenty-five times in the next twelve months.

Many photographers have earned impressive incomes from stock photo agencies for a long time. As shooters deposited more pictures with an agency, more dollars were generated. Most photographers looked at this royalty income as both a great way to earn money on a monthly basis and as a long-term strategy for a comfortable retirement. The wonderful advantage of stock is that you can go to Tahiti and fall asleep on a beautiful beach for a month while the agency is still selling your pictures. A regular stock income takes a lot of pressure off your shoulders.

The business of stock photography has changed radically over the past few years, however. Some of those changes are good, but many are not. Let me explain what's been happening; then I'll outline the best strategy for joining an agency and generating sales.

THE GOOD CHANGES

One of the burdens placed on stock photographers in the past was the necessity of making duplicate slides. Since images are sent out to clients on a regular basis, a single photo may be out for review to a dozen different companies at one time. My stock agency required forty to sixty dupes for each picture in their catalog. Duplicate

slides were also sent to foreign stock agencies for sales abroad. This was a tremendous expense in both time and money to produce the thousands of dupes required for each submission of new material.

Today the digital revolution has changed all this. A few stock agencies still require some duping because there are a few clients who like to see film. Most photo buyers, however, are able to readily use digital files. They can download images from the Internet or receive them as

Classic photos of fantasy vacation places like this shot of a coral island in Bora Bora made a lot of money for a lot of photographers in the past. Now a CD with one hundred high-resolution images similar to this one is available for a couple of hundred dollars royalty free. Stock photographers are trying to find new subjects and new styles of shooting to replace lost income.

e-mails or on a CD. I haven't made a dupe in about four years now, and it's saved me thousands of dollars in materials and thousands more in time.

Another positive development has been the dramatic increase in speed to access the Internet. Companies all over the world can purchase images online quickly and efficiently, expanding your ability to make sales.

In the past, the inclusion of your images in a printed catalog was very expensive. Paper catalogs were important advertising tools for presenting the best photography to photo buyers. They were (and still are) used as a resource for many years. Theoretically the total cost of printing and distribution of the catalog was borne by both the stock house and the photographers. The cost to each photographer was typically about $400 per image. If you had only ten shots included, the tab would be a serious chunk of money.

Today extensive Web sites have largely taken the place of paper catalogs. Stock agencies can show thousands of images without any cost accruing to the photographers. This is a significant savings for everyone.

THE BAD CHANGES

In the past few years, there has been a consolidation in the stock photography business similar to other industries, such as banks, airlines, and oil companies. This gives each mega-agency more money to promote your work, but the downside is that each company is no longer about photography and photographers. It's all about the bottom line. While every company is in business to make money, the personal concern about the employees and the shooters is largely gone. When I first joined an agency in 1987, the owner took pride in seeing his company grow and seeing his photographers become successful. His personal goal was that every photographer made at least $50,000 per year in stock; and when we achieved that, he was as happy as we were. It was a wonderful relationship both professionally and personally. When he sold the agency to a large corporation, everything changed. The corporate

employees come and go so often, I hardly know any of them.

Another obvious change for the worse in the stock business is the competition. There are many more photographers vying for sales, and there are millions upon millions of images available. How many pictures of a lion does an agency need? How many shots of lightning, smiling babies, power plants, the Eiffel Tower, sunsets, and roses can a stock house store before they close the files to new submissions in those categories? Even if the categories are open to new submissions, with hundreds or possibly thousands of shots in a single file, the likelihood that your images will sell is small. It is true that there are thousands of photo buyers purchasing literally millions of images every year; but as more and more photographers join the agencies, it is increasingly difficult to make as much money as in the past.

When I joined my stock agency, there were seventy photographers. There are now several thousand shooters in the giant agency resulting from several mergers as well as many more new contributors under contract. Modern cameras are so sophisticated today that it's easy to take marketable pictures, and many people fantasize about being a photographer.

The most stunning change, however, has been the introduction of royalty-free images to the marketplace. The term *royalty free* (RF) means that the client who purchases the photo can use it for as long as he or she wants and for any purpose. The RF image can also be altered digitally in any way. The traditional licensing (TL) of photographs is different. A TL sale is limited in the number of times the photo can be used or its usage is defined by a specific length of time.

Classic icons like the Tower Bridge in London are also available on royalty-free CDs. In the early nineties I spent many thousands of dollars shooting famous destinations in Europe. While those images still earn money, the number of sales and the decreased prices make me think long and hard about investing in another major foreign shoot. In this rendition of the famous bridge, I altered the colors and digitally placed a crescent moon in the sky to offer a unique interpretation, hoping it can compete with the inexpensive RF photos.

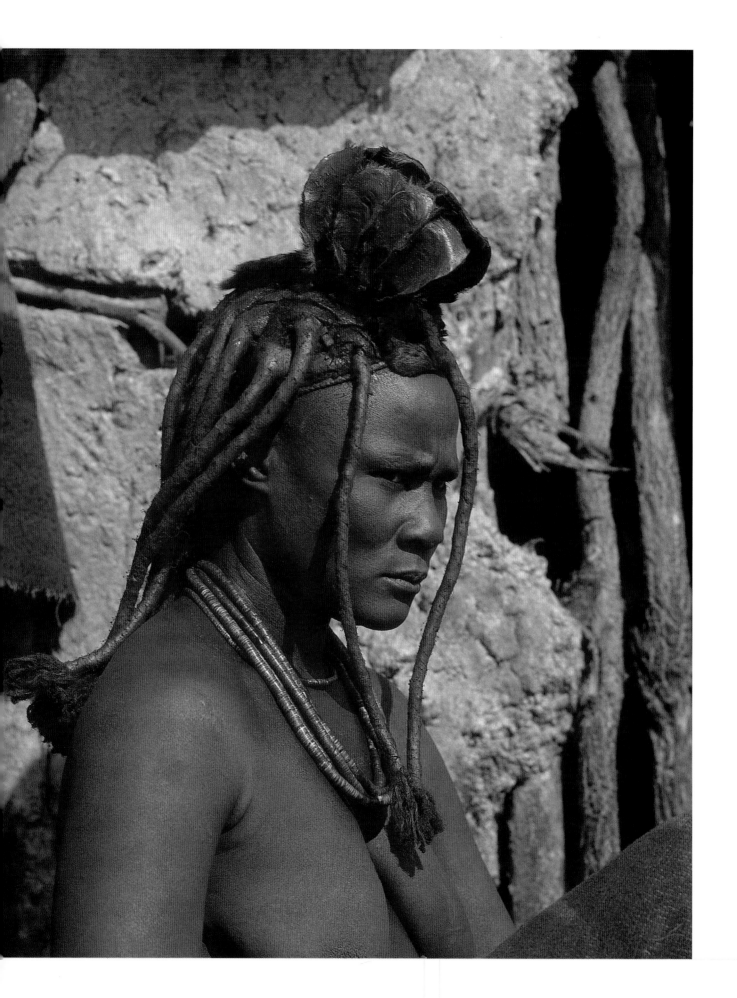

PHOTO AT LEFT. Model releases are required for all shots of people unless they are in a large crowd. This woman was photographed near the Skeleton Coast in Namibia. She is illiterate, never sees any publications, has no concept of lawsuits, has no money, nor does she have any need for money, and she lives two days by car (of course she doesn't have a car) to the nearest city where a lawsuit could be originated. In spite of this, agencies still want a release. If you don't have one, they probably won't accept the image into their files.

PHOTO ABOVE. When you photograph people who are not recognizable at all, a release is not required. These Zulu dancers were photographed in South Africa.

For example, one-time rights means that it can only be used once, such as a magazine cover or poster. If a publishing company used a photo for a cover and then wants to use the same picture as wall decor in their corporate offices, they would be charged an additional fee. A billboard sale, on the other hand, would be defined by a contract for a specified time period such as one year.

When CD burners first became available, clever entrepreneurs thought they could make money by competing against stock agencies in price. They burned fifty or a hundred images on a CD and sold it royalty free for $200 to $300. The price per picture was very low, but they bet that they'd make their money in the sale of hundreds or thousands of CDs. At first, the pictures were low-resolution generic outtakes; in other words, they couldn't compete with the best of the best in stock agencies. As more and more companies started doing this, to stay ahead of the competition, the RF images got better and better until they were every bit as good as the best shots in a major agency.

Now, instead of buying an entire CD, many clients prefer to purchase a single RF image. They can download it from the Internet with an online account. The problem for photographers is three-fold. First, the royalty-free pictures can be used again and again with no further monies accruing. Second, the price for RF photography is much lower than in traditional licensing. For example, the average sale in the late nineties for a TL sale was about $500 per photo. Royalty-free images can sell for as low as $20 to about $200 on the high end. And third, the commission split is abysmal. Traditional licensing sales are typically divided 50/50 or at worst 45 percent to the photographer and 55 percent to the agency. RF sales are typically split 20 percent going to the shooters and 80 percent to the company.

Remember, all shooting expenses including travel, models, film and developing, insurance, equipment repairs, props, etc., are borne by the photographer. The only way to make money in the RF arena is to generate thousands and thousands of images regularly. This is very expensive, and the reduced percent of each sale makes the enterprise a financial challenge.

What is the point, then, in joining a stock photo agency? Can money be made? The qualified answer is yes, stock photography can still provide a serious source of income for you. But you have to approach the business intelligently.

JOINING A STOCK PHOTO AGENCY

There are two questions you need to ask yourself if you are seriously considering pursuing the business of stock photography.

1. Can I spend time and money creating a body of work without expecting a significant return on investment for a year or two?

2. Can I take direction from a photo editor at a stock agency and shoot what they tell me to shoot?

If the answer to both questions is "yes," then you are ready to seek out an agency that is willing to take a chance on working with new talent.

The two mega agencies today are Getty Images and Corbis. Getty is backed by oil money from the J. Paul Getty legacy, and Corbis is solely owned by Bill Gates. There are many other stock agencies that are smaller yet very successful like Bruce Coleman and Photonica. For a complete list, refer to *Photographer's Market* published by Writer's Digest Books. This is the best place to start in deciding which agencies you want to approach.

All stock agencies have a process through which you must pass that allows them to determine whether or not you will be an asset to them. You will fill out forms, submit transparencies or CDs, have an interview by phone, and then perhaps submit more images before a contract is signed. How many images they want to see depends on the company, but an average would be between two hundred and five hundred.

PHOTO AT RIGHT. Concepts are very important in stock photography. A client may request pictures that suggest fear, love, security, anger, joy, and many other ideas and emotions. New ways of expressing those ideas are needed constantly. This threatening grizzly has sold many times because it says fear, aggression, and strength.

It's absolutely critical that each and every slide or digital file they see be your very best. Examine every slide with a loupe or, if it's a digital file, enlarge it 100 percent on a monitor to make sure it's sharp and free of dirt. There must be no technical flaws. The subject matter must be creative and unique. In the early eighties, agencies were in need of every kind of image. As more and more photographers joined and the sheer number of slides increased dramatically, the stock agencies could afford to be more selective. At this time they are ultraselective, so your work must stand out from the crowd if you are going to get into an agency. First speak to a representative from the company and ask what they need. What requests do they get for images that cannot be fulfilled? If you can fill a niche in their files, you'll be welcomed into their company with open arms.

Study online catalogs of the stock agencies that interest you. See what kind of images your competition is producing. If an agency has an extensive collection of medium- and large-format landscapes of the American Southwest, it doesn't make sense for you to submit a portfolio of 35mm slides of the same areas. Even if the agency accepted your work, the photos wouldn't generate significant income for you. On the other hand, if the stock house had few panoramic landscapes, this might be a niche to explore.

Initiating contact with one or more stock agencies means that they assess you and your work, but at the same time you must analyze them. Most importantly, you want to know if they provide guidance in helping you shoot salable

PHOTO AT LEFT. The guidance a stock agency can give you can often prove to be invaluable for everyone concerned. That's why it's so important to apply to a company that really wants you to produce for them and will help you with concrete ideas. When the film *Twister* first came out, the owner of my agency asked if I could digitally create a classic shot of a tornado. They had received many requests but didn't have any good shots in their files. I went home and experimented with a farmhouse shot in sunrise lighting and black storm clouds. The result was the image you see reproduced here. This picture has subsequently sold many times including my most lucrative sale for a single image: $18,500.

images. Can you call your photo editor anytime with questions? You'll want to know if they have a serious online presence. Is their Web site easily navigated so clients can easily find pictures and download them for immediate use? Does the agency have international agreements whereby your work is sold overseas? This is a big market, and you don't want to lose out. My agency has contracts with stock houses in more than thirty other countries.

You'll also want to know what the commission split is both for traditional licensing and royalty free. How often are you paid—monthly or quarterly? Do you have a choice whether your work is sold TL or RF, or does the agency decide? How long does it take from the time your pictures are submitted to the time they are processed and available for clients? Two weeks? Two months? When you submit slides, does the agency charge you for scanning them? Will they accept high-resolution digital files from your own scanner or a digital camera? The answers to these questions will help you choose which company to join.

EXPECTATIONS FROM STOCK

When I first joined a stock agency, the basic formula for expected income was $1 per slide per year. With thirty thousand slides on file with an agency, this would translate to about $30,000 per year. The type of photography could impact this calculation, however. Landscape and travel pictures are what most of us love to make, and the competition has always been more intense. Thus, the income per photographer is less especially if the originals are 35mm. If you can gain access to big industrial locations, such as steel manufacture, automobile factories, and oil refineries, you'll make more than $1 per slide because so few people can shoot these subjects. Maybe you'll make $4 to $5 per transparency per year.

With the introduction of royalty-free photography, the income for most stock shooters has been reduced; and the formula used to estimate annual income is really no longer valid. Fifty thousand royalty-free pictures can equal the income of perhaps five thousand traditional

Here is another image I produced at the request of my agency. When *Jurassic Park* was released, I was asked to create dinosaur pictures. I bought a detailed model of a Tyrannosaurus rex, had it airbrushed to simulate reptilian coloring, and then photographed it. I combined the T. rex with a grove of dead trees taken near Mount Rainier in Washington, and it has also sold many times over the years.

If you are in two or more stock photo agencies, make sure you don't submit the same image to more than one. Many photographers take this classic picture in Hollywood, California. If two agencies have the identical picture taken by two different people, there is no liability; but if two agencies have the same shot by you, that's a big problem. Neither of them will be happy, and you will jeopardize your relationship with both of them.

licensing images because the money paid for TL is so much more than RF.

The area of stock that generates the most money is people photography. Lifestyles, families, friendships, businesspersons in action, grandparents with grandchildren, student relationships, racial minorities, nightlife, and medical emergencies are the subjects that earn photographers consistently good incomes. These files need constant updating because styles change: hair, clothes, makeup, decor, cars, and even cell phones change every two or three years. If you want to make excellent money, this is a great place to start.

MODEL RELEASES

When photographs of people are used for advertising purposes, a model release is always required. The pictures used in the editorial market, such as a magazine article or newspaper piece, haven't been under such close scrutiny until the last few years. Today, because our society is so litigious, most agencies won't accept photographs of recognizable people without a release. Even if you took pictures of an Amazonian Indian tribe deep in the jungle with no access to printed media, no understanding of lawsuits, and no money to sue even if they wanted to, they still want a model release. I think this is ridiculous, but my agency and others don't care what I think about this. They still want the release.

What do you do if your models are illiterate? If they can't read or write, you simply ask them to mark an X on the signature line, then have the release witnessed by your guide or a shooting companion. This will suffice. In explaining what the release means to someone who can't read and who may not truly understand the concepts contained in the verbiage, I tell them that they are giving me permission to show the pictures in my country. I speak to the models through a translator, and she helps explain what I'm asking. This always seems to satisfy them. Trying to make them understand the total ramifications of stock photography in the U.S. and elsewhere is pointless because they often have no frame of reference.

Property releases are also required when you photograph privately owned structures, such as homes and office buildings. If the picture is a distance shot that shows many structures, you don't need one. But if the main subject is a private home, your agency is going to require a release.

I always use model or property releases that are very simple in their language so the person signing the agreement isn't intimidated. Don't use too much legalese and frighten someone into refusing to sign.

CONTRACTUAL EXCLUSIVITY

Some stock agencies require you to sign a contract that prevents you from submitting work to other stock houses. I would recommend that you don't limit yourself this way unless the company has international agreements with at least twenty stock photo agencies to supply them with photographs from the U.S. Some of the foreign agencies should be in prime markets such as London, Paris, Barcelona, Berlin, Rome, Toronto, Hong Kong, Tokyo, and Seoul. Then and only then should you sign an exclusive contract.

Another contract offered to photographers upon joining an agency is nonexclusive, allowing you to join other stock houses. However, they usually prohibit you from submitting the same or similar images to anyone else. They want exclusivity only on the shots they represent. I think this is fair.

Photographs of people doing things always sell if they
are executed well. Women and minorities in the work-
place, at home, shopping, cooking on a barbecue, and
enjoying an upscale lifestyle are coveted by all stock
agencies. One of the most popular themes is women
doing what has traditionally been a man's job like this
firefighter I photographed in front of a burning house.
This shot has sold many times.

PHOTO AT LEFT. I created a very different concept in this image of a futuristic, digital city. I used photographs of circuit boards and then put the composite together in Photoshop. Sometimes concept pictures sell well, sometimes they don't. That's the difficult part about stock photography: It is total speculation. This one has sold only a couple of times.

PHOTO ABOVE. Stock photography encompasses every conceivable type of picture. The huge textbook market uses millions of images every year. Many of my nature pictures have been used in biology books. Few photographers use a scanning electron microscope, so I decided to create a collection of insects and other interesting subjects on the SEM. Using Photoshop, I colored the black-and-white images, and the sales of these have done well because there is less competition.

I have made a concerted effort to be diversified in my stock photography. I didn't want to be solely dependent on wildlife, nature, and travel sales. I thought if my work was represented in many categories, I wouldn't have all my eggs in one basket, so to speak.

This image was created when I heard that my agency needed a picture showing the human heart. I bought the plastic model Visible Man and glued the heart in place. I painted it with phosphorescent magenta, then photographed it with a black light. It has sold many times for elementary, junior high, and high school textbooks.

Artistic pictures of industry are valuable stock. This sandwiched photo of a silhouette and a rainbow can be used for a cover on magazines devoted to many different kinds of businesses, such as insurance, concrete, construction, emergency medicine, environmental consulting, and iron workers. It has sold for other purposes as well, including an annual report and advertisements.

identifying markets for your work

AS DISCUSSED IN THE PREVIOUS CHAPTER, an income from a stock photo agency takes the pressure off of constantly worrying about your next sale. However, most stock shooters also market their own work for additional income.

Successful photographers must be creative in two arenas. First, they must use their creativity with their camera to produce salable images. Second, they must be just as creative—or more so—with their marketing skills. If your images are fantastic but they sit in a file cabinet at home so no one can see them, you'll starve. We who are artists don't like the business end of photography. Too bad for us. But if you like to eat, you had bet-

PHOTO AT LEFT. Assignments for wildlife, nature, and travel photography are few and far between because there is so much great stock available. Why should a publisher pay someone several hundred dollars per day to shoot a raccoon when there are thousands of pictures already in stock libraries? And assignment work offers no guarantee that the photographer will be able to get the quintessential shot. When clients look at a stock selection, they can immediately determine which image fits their criteria; and it will cost them much less than if an assignment had been given.

ter learn how to sell your pictures. In the beginning of my career, I had to deal with the same issue. I hated selling anything, especially my photography. To succeed I had to force myself out into the marketplace until it became less painful to do so.

GETTING PAST THE FEAR

Two things helped me overcome the fear of showing my work to prospective clients when I was starting out in photography. I knew I hated face-to-face meetings with people who reviewed my portfolio. Even though I was proud of my work, I didn't like the entire scenario of knocking on doors. Perhaps my expectation of rejection made the ordeal too uncomfortable. Instead, I learned to use the mail. I could send a package of my slides to magazines, card companies, galleries, and advertising agencies and never see their expressions as they looked at my work. This was totally painless, and I realized there were thousands of prospective photo buyers all over the country. I could send out dozens of packages a month and never leave home.

Looking through the book *Photographer's Market*, I spotted the magazine *Journal of Psychoactive Drugs*. They only pay $50 per cover photo, but I wanted a cover credit on this prestigious medical publication. According to the information in the book, the magazine uses computer-generated abstracts and other types of avante-garde images. I submitted these four images among others and was rewarded with several covers.

The other thing that helped me deal with the submission process was understanding that a rejection was not a personal affront. It took me a few years to realize this. I began to look at my slides as simply a product to sell, as if I were a salesman promoting a line of leather goods or farm machinery. If someone didn't like the leather handbags I was selling, I'd simply go on to the next prospective buyer and show them my samples. I wouldn't be offended, hurt, or feel dejected if they didn't buy. It's just business; several rejections always equal one sale. It is true that one's photography is a personal, artistic expression; but the images are still products. Some people will like them and some won't. As soon as I became emotionally detached from the preprinted rejection letters, I was able to send out many more submissions and consequently made more money.

ASSIGNMENT VS. STOCK

The two arenas in which photographic sales fall are assignment work, where you are paid per day or half day (or longer perhaps) to produce specified photographs, and stock, where a client purchases the right to use images you already have in your library. Advertising as well as editorial clients use both means of procuring photography.

Assignment work pays very well. Average per diem fees for commercial photographers in Los Angeles are around $1,200 to $1,500 plus expenses. But this kind of employment is usually reserved for photographers in every aspect of photography *except* wildlife, nature, and travel photography. Shooters who specialize in architecture, food, sports, products, cars, fashion, glamour, executive portraits, and other photographic disciplines get paid by the day or by the job. They turn in their pictures and receive a check.

Why doesn't this apply to wildlife, nature, and travel photographers? The answer is because most pictures a client needs regarding the natural world or foreign destinations already exist in stock libraries. If a publication needs a picture of a cheetah, for example, it is obviously more cost effective to select an image from your personal files or from those of a major stock photo agency. Otherwise, they would have to pay you many hundreds of dollars per day to fly overseas and get the shot. And, of course, there is no guarantee that the weather will cooperate or that you can even find a cheetah in an ideal situation with good light.

The same applies to travel images. How many pictures of Winchester Cathedral must there be? How many times have the Maasai people of East Africa been photographed? Thousands? Millions? Why would a company hire a photographer to fly over there when they can find many existing slides ready for sale?

This is not to say assignments don't exist. Although *National Geographic* does buy stock photography, they routinely hire photographers to go on assignment all over the world. *Islands Magazine* also gives assignments. However, in order to make a living, you need a constant source of income. Assignments come and go, and the competition for them is fierce. But a steady stream of income is possible with your own collection of slides sitting in file cabinets right now. The question is, of course, how do you identify the various markets that are eager to see your work?

PHOTOGRAPHER'S MARKET

The single best resource for finding thousands of photo markets is the book *Photographer's Market* published by Writer's Digest Books. It is an annual publication, and every year there are new leads. The book is divided into chapters such as trade publications, consumer publications, stock photo agencies, galleries, book publishers, music publishers, and advertising.

I have used this wonderful book for many years with much success. Provided with each list-

PHOTO AT RIGHT. Using leads from the gallery section of *Photographer's Market*, I submitted a print portfolio of children to photography galleries and art galleries that periodically show photos. A gallery in Washington, D.C., purchased a print of this young Peruvian boy and his llama for $400. They were having a show in Lima, Peru, and this shot worked into their South American theme. My timing in this case was lucky; but the more times you submit work, the "luckier" you get.

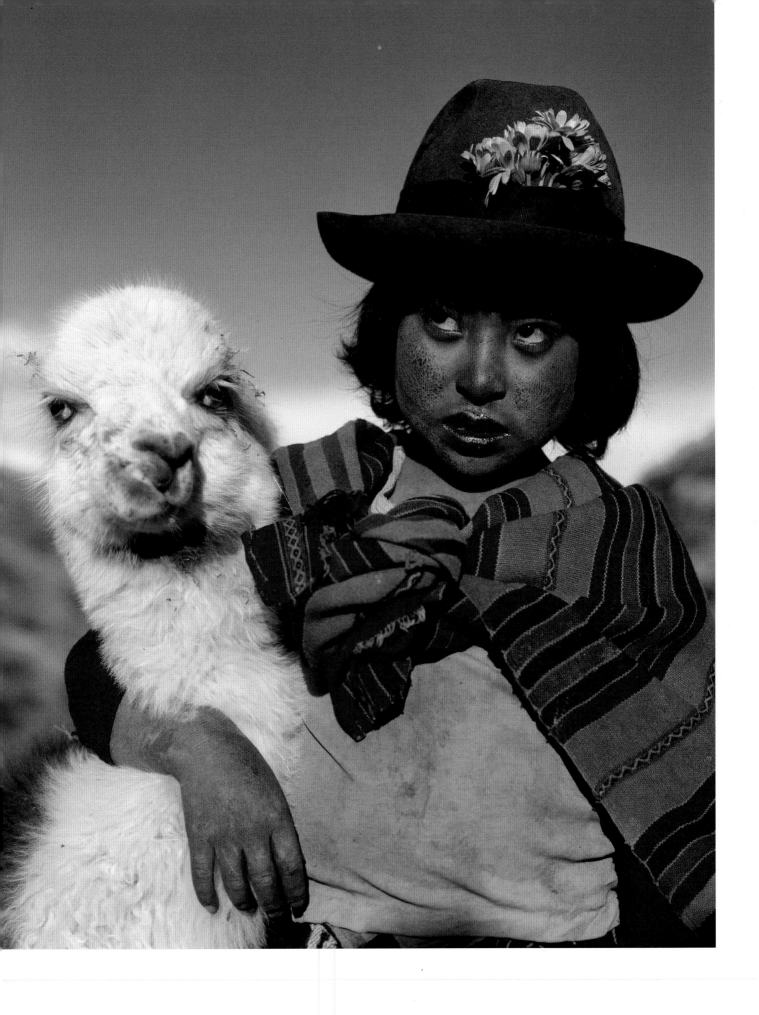

PHOTO ABOVE. When I am shooting in the U.S. or in other countries, my favorite subjects are not trucks. However, I know that shots like this sell to the huge market for transportation. The return on investment for any trip increases when you shoot a variety of subjects for a variety of markets. *Photographer's Market* puts at your fingertips many types of publications representing dozens of industries.

Another way you can find magazines in a specific industry is to visit the office engaged in a particular business. For example, a truck stop will sell as well as subscribe to several trucking magazines. My brother-in-law is in the packaging business; and when I went to his office the first time, I was amazed that he had a rack of at least six magazines entirely devoted to the packaging industry.

PHOTO AT RIGHT. Assignment work appeals to many photographers because it is not speculative. You know how much money you'll make versus the time invested in the project. I accepted an assignment to shoot business centers and transportation of Bangkok, not the famous tourist sites that have been photographed for years. I hired a car and driver to find vantage points to shoot the skyline, the skytrain encircling the city, the legendary traffic, major malls, and banking centers.

Make sure both you and the client understand beforehand who owns the pictures you take during the assignment. Do they own all rights? Can they use the images as much as they want and for any purpose, but do you also have the right to submit them to a stock agency? Can you include them in a future portfolio? Can you publish them on a Web site? These issues must be defined in the contract. Also, be sure to ask what film or digital format they prefer. This picture of Bangkok was taken with 35mm film because that's what my client wanted.

ing is the name, address, phone number, and contact for each company. The types of photographs needed are described, and the monetary budget for photography is often included. If you are just starting out, perhaps you can target markets that don't pay well just to build your confidence. When you have some photo credits under your belt, submit your work to the more prestigious and higher paying clients.

Most of the publications and companies listed in this book will be completely unfamiliar to you. Don't let that stop you from submitting your work if it applies to their needs. Many of them pay very well; and if they like your work, you can become a regular contributor. When I first started using this resource in the 1980s, I sold fourteen covers to a magazine published by an insurance company. It was called *Woodmen of the World*. The circulation was 500,000, but I had never heard of it before. They used my wildlife and nature images almost every month for a year and a half until they changed their format and went to illustration for cover art. When I submitted my work to them for the first time, they had never heard of me either. My photographs just appealed to them.

I save each year's *Photographer's Market* because some companies chose to withdraw their name from the book in subsequent years but still buy photography. If you only use the most recent copy, these firms can be overlooked.

Set a goal when you buy this book. For example, promise yourself that you'll send out one package every week to a prospective client. If you are more ambitious, send out three packages a week. Expect rejections, but don't let that get to you. Simply send the same materials to someone else.

BOOKSTORES

Bookstores sell more than books. They have many kinds of published materials from the U.S. and many other countries. I have often studied calendars, travel and nature books, magazines, and racks of postcards to get the names of the companies who publish and distribute these items. If the work I see published is similar to the

subjects in my stock library, I'll contact them with a submission. I have also used this information to inspire me to shoot something just for them.

For example, a line of animal cards that have been digitally altered to create a humorous situation may start me thinking about doing the same thing with my own shots. Or a line of hand-colored kids may encourage me to apply the same technique to romantic images of Europe I have in my files.

PUBLIC AND UNIVERSITY LIBRARIES

Libraries always have an extensive periodical section. Study the various issues to get a feel for what each magazine needs on a monthly basis, then write down the contact information.

Several years ago I found a photo magazine from Australia that I'd never seen before. I wrote them a letter with a list of articles I could write. My letter had a little tongue-in-cheek humor. I told them I promised to misspell words like *flavour* and *colour* if they used my work, then I closed with "G-day mate." I wrote for that magazine for a few years until they ceased publishing.

At a university library, I found a magazine called *The Journal of Psychoactive Drugs*. This prestigious medical journal is published quarterly, and they only use abstracts on their covers. Their payment was quite low—only $50 per image—but I wanted the cover. I submitted a selection of computer-generated abstracts, and over the course of two years I sold them four covers.

USING A MAILING LIST

You can reach hundreds of potential clients as well as artist and photography representatives by sending them a direct mail piece. A mailing list

PHOTO AT RIGHT. Another assignment I took was to photograph a Las Vegas showgirl in a dramatic desert location. One of the risks involved in taking a location assignment is the weather. Will the lighting be ideal? If not, is the client willing to pay your per diem to wait until it is? Will they pay for digital enhancement should the weather not cooperate? I was fortunate in this situation because good lighting can almost be guaranteed during most of the year in the southwestern deserts.

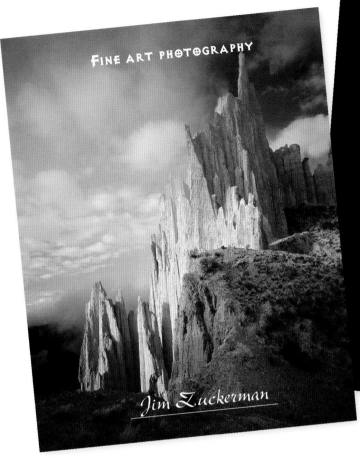

Mailing lists that target a specific group can put your photography in front of people and companies who may purchase your images, represent your work, or hire you for assignments. The promotional piece that you mail out has to be carefully considered. I like very simple, easy-to-understand postcards like the one pictured here (shown are both front and back sides of card). I always assume that people are very busy and don't have time to read a lot of text or look through many pages of pictures. I try to grab their attention immediately. If they are tantalized by what they see, my Web address directs them to my online catalog.

I am not suggesting that this ultrasimple design is the only method of direct marketing. Your taste may be very different. But don't include so many photos and so much text that your piece gets thrown in the trash because few people will take the time to look closely at your work.

provides you with preaddressed labels that you affix to a postcard, letter, or brochure of your work. This "shotgun" approach to marketing has been used successfully by thousands of companies and can work for photographers as well.

A company that offers these lists for sale is artmarketing.com. You can look at their Web site (the direct URL for the mailing lists is: www.artmarketing.com/ML/lists.html) or call them at (800) 383-0677 to request a free catalog. Some of the lists they sell include:

- 400 greeting card sales reps
- 500 photo galleries
- 750 interior designers
- 1,750 art publishers
- 180 corporations collecting photography
- 2,000 reps, consultants, dealers, brokers
- 300 book publishers
- 140 corporate art consultants

The catalog they send offers more than mailings lists. There are many resources to help you

market your work including newsletters, books, grant writing services, directoriess, and contests all designed to help artists sell their work. If you want to open a local studio, they even provide a list of people who should be invited to your opening. It's an invaluable resource that you'll want to use and refer to many times.

THE INTERNET

Even though I've been using the Internet for several years now, it still continues to amaze me. The amount of information accessible to everyone is simply astonishing. Any aspect of photography can be found on the Net. There are chat rooms, online stock agencies, contests, equipment for sale, and many photographers around the world who are generous with their help if you have questions.

Photographers looking for new markets will quickly realize it is a wonderful tool that is truly limitless. Start by defining what you're looking for. Very quickly the listings that come up take you in totally unexpected and often very valuable directions. For example, I just did a search using Google as my search engine for "Nature magazines." The results were mind-boggling: 1,230,000 listings. Obviously most of those won't apply to you, but many will. I found many magazines on every aspect of nature, books you can buy that list nature magazines, online directories for magazines dealing with conservation, outdoor recreation, wildlife, geography, wildflowers, environmental education, environmental issues in Asia, ecotourism, climatology, and much, much more.

Looking for someone to represent your work? Do a search for "Photography representatives," and again you'll have many choices to pursue. What about stock photo agencies that only exist online? You'll find them by doing a search for "Stock photography" or "Stock photography online." You have to wade through many listings that won't be relevant to your needs, but that's a small price to pay for the wealth of information available at your fingertips.

Try doing a search for "Selling photography" and see what you get. You will find listings of books

© Jim Zuckerman

about the subject, discussions among photographers about their successes and failures, and many Web sites where other shooters are selling their work. You can research the approach other photographers have taken and adapt your own efforts with these influences. You can check out their pricing, presentation, Web site design, types of images, and all the other aspects of selling photos.

The information you gather from surfing the Internet will get you started in many directions or perhaps only one direction. You will then modify your marketing techniques based on your personality, your work, and your clientele. If others can do it, so can you.

When a photograph is published, you lose control over how it is reproduced. This is very disappointing, but it's just the nature of the beast. This shot is tightly cropped from the original; but the graphic designer for Imacon wanted the ad to have maximum impact, so he focused on the intense eyes of the wolf.

anatomy of a
submission

I HAVE SUBMITTED MY WORK TO MANY companies over the past thirty years. Sometimes the client makes a purchase and sometimes not. Just because I've been shooting for a long time and have many credits in the industry, it doesn't mean that every photo submission I put in front of a publisher or advertiser is accepted.

Therefore, I am always thinking about how to improve my submission materials to make it easier for a photo buyer to assess my photography and to accept my proposal. Just as in an advertising campaign where consumers must absorb a message in only a few brief seconds, photo buyers are in essence the consumer and photographers are the advertiser. We must get our message across quickly before our package is discarded to the rejection heap.

There are three components to a submission: the cover letter, the photographs, and the packaging materials. Let's consider each one in detail.

THE COVER LETTER

The letter in your submission package is designed to do one thing: communicate to an editor, photo buyer, gallery owner, or the creative director at an advertising agency why you are sending him your work. You should be respectful of his time, which means brevity is of the utmost importance; and you want to give the impression you're a professional.

In writing a cover letter, some photographers feel a need to share their personal photographic goals, how they want to share their gift with the world, how photography has changed their lives, and their past accomplishments in photography or some other field of endeavor. Don't do this. No one cares. You will alienate the prospective client and identify yourself as a rank amateur. Perhaps after you establish a close relationship with a photo buyer, the two of you can talk about other issues; but initially keep it simple. The letter must only be about your images and why you are submitting them.

The other mistake photographers make when sending a submission to a potential client is they talk about their equipment. Again, no one cares. If they ask about your gear in a subsequent phone call or e-mail, fine, explain away. But

Jim Zuckerman

Baliem Valley, Irian Jaya, Indonesia

whether or not you use a Nikon or a Canon or whether your lenses are ultra-low-dispersion glass or soda bottles ground into photographic optics is irrelevant. The only time you should discuss equipment is if you send digital files on a CD and your original shots were medium or large format. If you want to emphasize that your pictures have exceptional quality because they were scanned from the larger format, do so in a single sentence or phrase, such as "All high-resolution scans were made from 4" × 5" original transparencies."

In the cover letter or on any identifying slide labels, don't include data such as f-stop, shutter speed, or film type. If you are submitting an article to a photographic magazine, this information is obviously important for the article but not for the initial contact. With all other photo buyers, it's never important. Don't burden them with unnecessary information that clutters up your package.

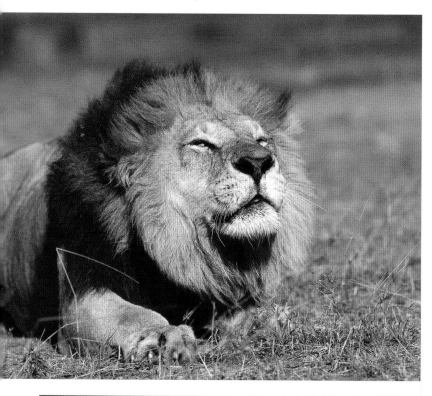

I consider each aspect of my submission packages very carefully, including the order of the prints. I also place a strong photograph on top so the person opening the envelope will see it first. The lion is a shot I would use for a calendar package because of the horizontal composition. The expression on the lion's face is compelling, and I would count on that to generate enthusiasm in a photo buyer.

I would choose the bottom left photo to be on the top of a submission to a fashion magazine or to a company that publishes a fashion catalog. The brilliant color and unusual angle show a unique vision—and they're always looking for new styles—while the sensuality of the image is attention-getting. I would chose the bottom right photo to be the first or second image of a submission package to a gallery where I was promoting my artistic digital work in portraiture. I would hope that the beautiful face and lovely colors in the image could make a strong impression on a gallery owner or curator.

If I were submitting a collection of flowers, I would place the far right photo on the top of the prints because it has such an unusual and beautiful blossom.

This kind of thinking is really guesswork. I don't know how someone whom I've never met will respond to my print submission, and I ultimately have no idea if my carefully chosen *first impression* print will help sell my proposal. My point is that I try to do everything possible to put the odds in my favor. Great photography is certainly at the heart of the business. But I'm convinced that considering the little things makes a major contribution to my success in photography.

What follows are four cover letters I've written with an accompanying photo package. You don't have to use my verbiage verbatim, but these letters will at least give you a place to start. They are exactly as they were written.

If you are proposing a project that requires a more detailed explanation, such as a book proposal, your letter must necessarily be longer. However, the same rules apply. Be succinct. Make every word count toward your end goal, and don't bore the person reviewing your package.

THE PHOTOGRAPHS

I have submitted my work in many forms over the years. One of the first submissions I made consisted of type R prints. Then for a long time I sent transparency originals or duplicates in slide pages. I professionally mounted and labeled the

Mr. Dave Schonauer December 13, 1999

AMERICAN PHOTO
1633 Broadway, 43rd floor
New York, NY 10019

Dear Dave,

Please find enclosed the CD ROM submission about which we spoke on the phone. It consists of eight themes with low resolution images for your convenient viewing. Although I've suggested these eight categories, please feel free to mix and match the images to suit your editorial preference.

Should you wish to publish one or more pieces featuring my work, let me know and I'll supply the text plus the high resolution files (38.5 to 50 megs) on another CD.

Thank you for the courtesy of reviewing my work.

Sincerely,

Jim Zuckerman

Encl.

December 5, 2001

Mr. Christopher Addison
ADDISON/RIPLEY FINE ART
1670 Wisconsin Avenue, NW
Washington, D.C. 20007

Dear Mr. Addison:

Please find enclosed my photographic portfolio entitled "Celebrate the Children" for your review. Would you kindly consider my work for a show in your art gallery. I have included a biography as well as an artist's statement.

For additional examples of my work, you may visit my website at: www.jimzuckerman.com.

Thank you for your courtesy in reviewing my work. I have supplied a SASE for the convenient return of these materials.

Sincerely,

Jim Zuckerman

Encl.: color portfolio, biography, artist's statement, SASE.

cover letters

film and sold many photographs, articles, and book ideas using this method of presentation. When CD burners became available and we could create portfolios for viewing images on a computer, I submitted a number of packages using this new technology. I designed slick-looking CD covers, and this new method of submitting my work also proved successful.

I have come full circle, however, in the way I now send my work to potential clients. I send prints. Using an Epson 2200 printer, I can produce exquisite prints with saturated color and crisp detail. The quality of these prints is actually superior, in my opinion, to conventional photographic printing in a darkroom; and they are much less expensive. Instead of paying about $14 for a custom 8" × 10" print, I pay only about $1 for the paper and ink. And I've got all the advan-

December 20, 1998

Mr. Marc Brown
BROWN TROUT
4 West 4th Avenue, #200
San Mateo, CA 94402

Dear Mr. Brown:

Would you please consider the enclosed theme of dinosaurs for a one-man calendar? I can supply high-resolution scans derived from medium-format transparencies upon your request.

I've enclosed an SASE for the convenient return of this material. Thank you for your courtesy in considering this submission.

Sincerely,

Jim Zuckerman

Web site: www.jimzuckerman.com

June 23, 2000

Art Department
PORTAL PUBLICATIONS
201 Alameda Del Prado, Suite 200
Novato, CA 94949

Gentlemen or ladies:

Please find enclosed a CD-ROM consisting of 18 high-resolution (approximately 40MB) wildlife and travel images for your consideration. I have included a thumbnail page of the same pictures for easy reference.

You have previously published some of my photographs as posters, namely "Sunset Storm," "Snake River," and "Alaska Reflection."

Thank you for the courtesy in reviewing my current work.

Sincerely,

Jim Zuckerman

Enclosures: CD-ROM, thumbnail page, signed agreement.

tages of doing it myself: total control, no waiting, the copyright symbol is easy to include, and I can add a design component to each photograph (type, a border, textured background, and drop shadow).

The reason I send a print presentation is because when photo buyers first open my package, I want the images to hit them in the face. Neither a CD nor slides do this. A CD submission necessitates close examination on a computer monitor. This only happens when the person gets around to it. Transparencies (perhaps with the exception of 4" × 5" chromes) can't be fully appreciated until they are studied on a light table through a loupe.

Prints, on the other hand, are ready to be admired the instant someone looks at them. If the photographs are excellent, I am betting on the fact that the photo buyer who opens a submission will be drawn into seeing the rest of the package based on his or her first impression. I believe that a CD and a pile of slides don't have the same immediate impact that a beautiful print does.

I always keep in mind that these people get a lot of submissions. After looking at hundreds of photographs every week, they can get jaded. Thirty-five-millimeter slides are especially tiresome to look at because they have to be louped. After looking at a few hundred slides in a morning, an editor gets visually tired. I try to make my packages compelling so photo buyers want to consider my proposal carefully and with deliberation. First, I must grab their attention, which is why I now submit a nicely designed print portfolio. Once they decide to purchase one or more photographs, I send a CD with the high-resolution scans.

If you prefer to use the traditional method of submission, slides, there are simple ways of making the presentation appealing, easy to review, and more professional. First, label all the slides completely. Don't be vague. If your work includes wildlife, provide the Latin name for each animal. Even if you photographed commonly known species like raccoons, rabbits, or lions, the inclusion of the Latin name makes you look more pro-

fessional and saves the client time in finding that information should they need it. There are many Internet sites that put this information at your fingertips. If the subject of your photo has a claim to fame, explain that on the label. It may help sell your work. For example, the highest mountain in Europe, the largest lizard in the world, the mosquito that carries malaria, the first mission in California are phrases that make your slides more valuable to a buyer.

Note that in the following labels the dates have been deleted from the copyright notice.

A TYPICAL LABEL FOR A LANDSCAPE PHOTO:

© Jim Zuckerman
Tupelo and cypress trees
Merchant's Mill Pond State Park
North Carolina

A TYPICAL LABEL FOR A WILDLIFE PHOTO:

© Jim Zuckerman
Juvenile cheetah (Acinonyx jubatus);
Kruger National Park
South Africa

A TYPICAL LABEL FOR A TRAVEL PHOTO:

©Jim Zuckerman
Petronas Towers, tallest buildings
in the world;Kuala Lumpur,
Malaysia

A TYPICAL LABEL FOR A FOREIGN MODEL:

©Jim Zuckerman
Bedouin woman in wedding veil
Jerusalem, Israel
Model released #jz 213

Never handwrite the labels unless your handwriting looks exactly like a font. There are many inexpensive label programs that produce professional-looking labels.

All of the slide pages you use should be new.

PHOTO AT RIGHT. When I submit my work I am always trying to appeal to people on an emotional level. I never really know if this psychological approach works, but I assume that photo buyers have feelings too and when they see a photo that is ultra cute or humorous they will respond by finding a use for the image. Serendipitous photos like this one don't happen often, but I recognized it immediately as a salable shot. I grabbed it from the car as I was stuck in traffic in Raleigh, North Carolina.

Jim ZUCKERMAN
818 360-1198

Submission: Malyasian borneo

© jimzuckerman 2004

A CD submission should be dressed up by making a custom label for each disk. Here are two examples of designs I've used. In creating your own design, don't forget to take into account the hole in the center of the CD. The blank, precut CD glossy labels are placed in your desktop printer and printed normally.

Don't submit your work in old plastic pages with scuff marks. It looks like you're trying to save a few pennies, which you are. This degrades your perceived image.

If you are submitting medium- or large-format transparencies, ideally they should be mounted in black die-cut frames made from card stock. (Mine are 5" × 8" with a score down the middle so they fold into 4" × 5". In the center there is a window for the 6cm × 7cm transparency.) Any printer can do this for you. For additional money, your name can be embossed in gold foil on the front, then a computer-generated label can be placed on the bottom with identifying information. Photography is a visual art, and the way you present your work is as important as the work itself. It tells a potential client that you pay attention to detail, that you care about your work,

and that you are the consummate professional. Often the perception that you have these qualities will tip the scales in your favor in the decision to hand out assignments, award a book contract, or buy stock photos.

If you prefer to send a CD-ROM instead of prints or slides, you can set it up as simply a catalog of images or something more elaborate. Some photographers create an interactive slide show. Others prefer to add music and graphics to their digital presentation. If you know a company has a television in their office with a DVD player, you can burn a presentation onto a blank DVD to be viewed on TV.

To make the CD or DVD submission slick, create an attractively designed label for the disk as well as for the jewel case. I use the Stomper CD Labeling System for my CDs, and I always print the CD labels on precut glossy stock. The matte precut labels don't reproduce color well.

THE PACKAGING

The materials that comprise the rest of your package include a mailing label, envelope, and stiffeners that protect the contents and keep the submission flat. Preprinted mailing labels with your name, company name, and address look professional. If you don't want to go to the expense of paying a printer to make them, a very nice label can be created in Photoshop, QuarkXPress, or Microsoft Word. If you use Photoshop, a color photograph can be included in the design of a label. Use a computer or typewriter to print out the client's address.

I am always thinking of ways to make my submissions stand out. Everything I can do to promote my business ethic and my artistry is worth

the investment and effort. One of the techniques I've used is to buy black 9" × 12" envelopes (the following Web site is one source to find them: www.actionenvelope.com/colored-envelopes-black-envelopes.html). Black is a very unusual color for an envelope and immediately distinguishes my package from the entire pile of mail a photo buyer receives. The typical manila envelope is common. You could choose other colors or styles, but this is what I prefer. The self-addressed return envelope can be the less expensive manila type.

The stiffeners you use shouldn't be old boxes cut to fit the mailing envelope. Buy precut black plastic stiffeners. They are more attractive and have a cleaner look. They are also lighter in weight, which saves on postage. Use two of them, placing the prints, CD, or slides between the two pieces for protection.

Always include a self-addressed, stamped envelope with sufficient return postage. This guarantees the return of your material, which then allows you to send it to another company. The label on the return envelope bears your address. In an inconspicuous place on the label, put a code (such as WDB for Writer's Digest Books) so you know from which company the material is being returned. Sometimes when your submission is rejected, the photo buyer neglects to put a letter inside explaining the reason the material was unsuitable for them. Without a letter of any kind, you won't know who is returning your photography if you have many packages out at the same time. The code will help keep track of your submissions.

Jim Zuckerman
THREE FINE ART PORTFOLIOS

www.jimzuckerman.com
818 360-1198

I have a friend from England who self-published a line of notecards of well-known locations. I met him in Venice, where he was photographing famous views of the city like this shot of the Rialto Bridge. He would then have a printer produce beautifully designed gift boxes of cards featuring his pictures. Armed with samples, he would present his line of cards to every retail outlet in Venice he could find. Millions of people visit this city every year, so his market was huge. His key to success was that each place he developed had a very high concentration of tourists.

self-publishing

THOSE OF YOU WITH ENTREPRENEURIAL spirits will undoubtedly be thinking about publishing your own work without the financial support and the distribution channels of an established publishing company. There are two advantages to doing this. First, you can make more money. In fact, you make all the money. Second, you maintain complete artistic control over your finished product, whether it's a poster, notecard set, calendar, or book. The choice of paper stock, the design, which photos are used, the font style, and all the other decisions that must be made are entirely up to you.

There is only one disadvantage to publishing your own work. It's called risk. If your product doesn't sell, you will lose money. You have already spent money to create the pictures. Your investment in travel, models, film and developing, equipment, photo education, a computer, and time has already been substantial. But this money was spent on doing something you really enjoy. Self-publishing requires expenditures of a different nature.

PRODUCING A PRODUCT TO SELL

There are two ways in which you can produce a printed piece. You can hire a graphic designer to create the design and prepare the final digital file for the printer, or you can do everything yourself. If you choose the former, the fee can run the gamut from very affordable for a simple poster design or greeting card line to hundreds or thousands of dollars for a larger project like a coffee table book.

If you elect to do the design work yourself, you will need a working knowledge of the program QuarkXPress. It is a page layout program that allows you to work with text and photos; but it is important because its ability to reproduce text with maximum sharpness will make your product look its best. The Postscript fonts are designed for use for film and plates in the printing press. You can still go to press using TruType fonts in Photoshop, and your work will look good. However, the type in your piece will look better if it is produced in Quark.

Choosing a design for your product shouldn't be difficult. There are so many posters, calen-

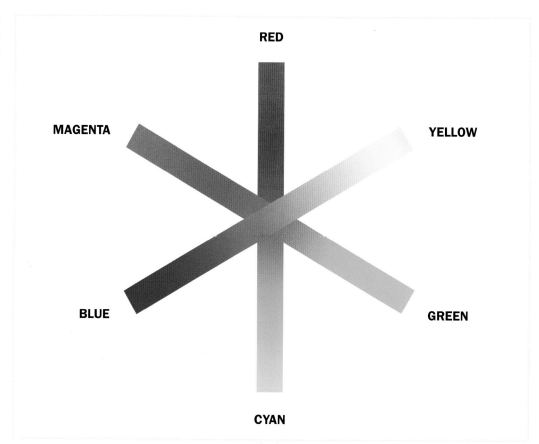

The colors opposite each other are called complements. They have a special relationship with each other. For example, green and magenta are complementary colors. If you add magenta, the green is decreased. Similarly, if magenta is subtracted, the amount of green is increased. This is how color can be altered in Photoshop as well as on a printing press. On the monitor, you change the color relationships with slider bars in color balance or the graph in curves. On a printing press, the color is altered by adding or subtracting ink using the same relationships you see on the color wheel.

dars, notecards, mugs, place mats, etc., available that any of these can serve as an inspiration for your own design. Keep a file in your office of examples of published designs; if you can create the artwork that complements your photography, the initial investment in a self-publishing venture will be reduced.

The scanner used to digitize your photography should be of good quality. It doesn't have to be a drum scanner, but the dynamic range should be at least 3.6 and above. The Nikon 4000 and 8000 scanners are excellent, as is the Polaroid SprintScan 4000. The Imacon FlexTight Photo scanner is now affordable and is a superior scanner. All the photos in this book were scanned with this model.

The finished digital file burned onto a CD is given to the printer, and it is from this that the printing plates are made. Speak to a representative from the printing company so you know exactly what to give them. All the photography included on the disk must be in CMYK, or cyan, magenta, yellow, and black. This is the color space printing presses use. It corresponds to the actual inks laid down on the paper. The desktop scanners we use produce digital files in RGB, or red, green, blue. Therefore, in Photoshop, you must convert each photograph to CMYK using the pull-down menu: Image: mode: CMYK. Each file will suddenly become 25 percent larger because instead of three colors it is now four.

Unfortunately, CMYK doesn't offer the same kind of color accuracy that RGB does, especially in the blue-purple-magenta area of the spectrum. To bring back the original hues once you've converted the colors, you'll have to use the various methods within Photoshop to restore the integrity of the original photo. I use curves, hue/saturation, and levels most of the time. Sometimes it's impossible to retain certain shades of color.

Once the layout design is complete and the photos are converted to the correct color space, you have several decisions to make in consultation with the printer. You must choose the size of the final piece, the type of paper stock, whether the photo will be bled (to the edge of the paper) or if it will have a border, the width of the border, whether you'll have printing on both sides, and

what type of coating will be applied to the paper. Coatings are an important part of the decision-making process because they dramatically affect the look of the final product. Examples of coatings are aqueous matte, aqueous glossy, UV, and spot varnish. You'll want to see examples of these choices and discuss prices before you make a decision.

At this point your project goes to press. I would strongly suggest that you do a press check. This means watching your job come off the printing press. Even at this stage the pressman can tweak the colors. If the print run is looking a bit too blue, you can ask that the color be warmed up a bit by adding more yellow or perhaps a little magenta. Make sure you understand the color wheel before you start requesting changes.

MONETARY CONSIDERATIONS

Lithography is relatively expensive when you look at the total bill. However, if you calculate the price per piece, the cost is very low. The more copies you print, the cheaper each piece gets.

For example, let's say a four-color 24" × 36" poster printed on one side of the paper costs $1,500 for one thousand copies. Each poster costs $1.50. If you printed two thousand copies, the total cost would most likely be $1,750. You've doubled the number of posters for only an additional $250. Five thousand posters may only cost $2,200. Now each piece costs only $0.44. These figures are only examples and will vary depending on the printing company and all the variables that go into determining the final cost of the job.

The cost per piece is now very low but the initial outlay of $2,200 isn't pocket change. You will increase the profit margin by printing more copies, but the risk factor is also increased. It is very tempting to pay for a large print order to maximize profits, but you will only be profitable if you can sell your product.

Self-published calendars, books, and gift boxes of notecards require significantly larger investments because there is much more design work, paper, and press time involved. All publishing companies go overseas for most of their printing needs. The cost savings is significant. It can be 50 percent less expensive to print in China, Korea, Thailand, and several other countries. The quality is superb, but you still should be involved in the entire process including a press check to maintain quality control. The best way to locate a printer in another country is by referral. Contact a publisher and speak to the production manager. He or she should have no problem giving you the names of printing companies with which she has a satisfying relationship. Alternatively, you can search the Internet.

It is not possible for me to give examples of exact costs for individual projects because there are so many variables. If you want to cut costs as much as possible, you'll use thinner paper stock (for example, 80lb as opposed to 100lb), a less expensive coating (aqueous as opposed to UV), and if your project is a calendar, you would opt for twelve months instead of sixteen months.

If quality is the number one consideration, then the choices would be very different. You'd use a heavier paper with a UV coating; and instead of four colors, you might do a six-color run to pick up very subtle colors unattainable otherwise. The additional colors could be a gold or silver foil, a custom ink like fuchsia or chartreuse, or what's called a "touch plate," which increases the saturation of a particular color. These methods of making your printed piece outstanding are expensive, but they change the look of your images from that of poster quality to fine art.

DISTRIBUTION

If you don't have a way to bring your photography to market once it is printed, you've got a serious problem. When I first tried self-publishing many years ago, I enthusiastically printed a poster that I thought was perfect for the Christian market. When I tried to get distribution after I spent $2,000 on graphic design, color separations, printing plates, and the posters themselves, none of the distribution channels I contacted would carry it. Some said it was too big, others told me it wasn't right for their market, while other companies wanted a line of products rather than just

PHOTO ABOVE AND RIGHT. You don't have to travel around the world to be successful at self-publishing. Humorous and adorable pictures of pets always sell well and probably always will. To find people who have puppies and kittens of various breeds, contact any veterinarian or pet store. They know how to contact owners and breeders of anything you want to photograph. Once you've taken pictures of a few pets and the owners are happy with the prints you've given them (this is a very inexpensive way of paying them for their trouble), you'll have enough referrals to keep you busy for a long time.

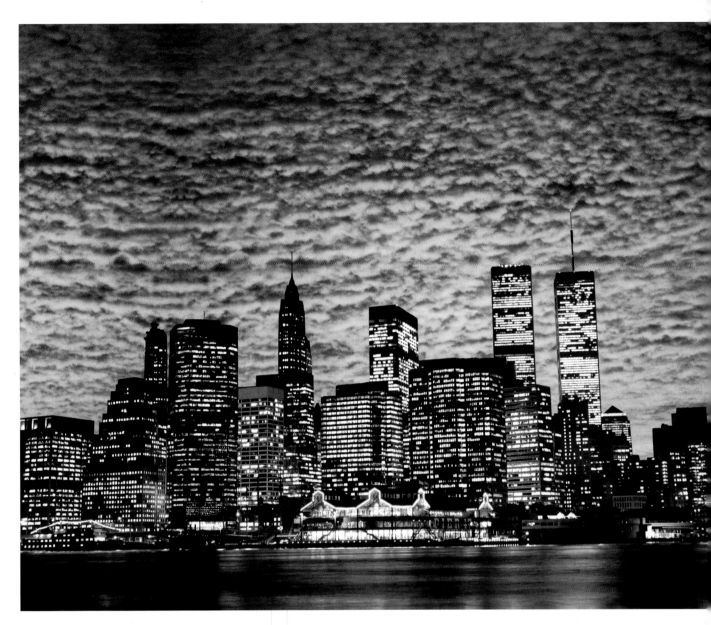

PHOTO AT LEFT AND ABOVE. Many people are buying pictures of New York and the World Trade Centers now. We don't want to forget the terrible attack on the U.S., and we miss those powerful symbols of a free people and a free economy. There are many items that can be produced with these images if you happen to have them in your files: posters with patriotic slogans, T-shirts, mugs, notecards, or even a small, commemorative book in black and white. You could donate part of the proceeds to charitable organizations working with the victims of September 11, 2001.

a single item. In the end, I finally sold two thousand copies at a discount and broke even. But it was a good learning experience: Find a market for the printed pieces before you invest.

The best way to approach a distributor is with a complete presentation. Do a mockup of your idea and know all the costs involved. For example, if you want to produce a poster, use a desktop printer to show the distribution company exactly how the finished product will look. Print out an 8" × 10" or 11" × 14" complete with the graphic design, any caption you want to include, and your photo credit. As part of the package, itemize the specifications of the poster, including size, paper stock, coating, and the number of colors.

Here are the specs for a self-published calendar I proposed to a local bank. I got this information from the printer after we consulted on the job. The "4/4" refers to four-color printing on both sides of the paper, typical of calendars.

11" × 14" trim
32 pages plus cover
4/4 & Overall UV outside front/back cover
Cover: 95# topkote gloss cover/32 pages
100# topkote

PREPAID COMMITMENTS

I'm sure you've seen promotional calendars that businesses use to give to their customers. The business name is printed somewhere on the calendar so it stays in front of the recipient for a full year. Large companies print thousands of calendars with a variety of themes: landscapes, exotic cars, pretty girls, and so on. They solicit hundreds of businesses and sell a few hundred pieces to dozens of companies. The combined print run turns into a nice profit.

You can do the same thing with your photography. Printing the calendar is easy. The challenge is putting on a salesman's hat and marketing the idea. If this interests you, talk to some of the local businesses you know and see if they would be interested. You could make a mockup of a sample calendar with a desktop printer. Few non-photographers can visualize what you have in mind, so help them with a sample. If there is interest in your project and you'd like to venture into this field, get some prices from a printer, then make a formal presentation to potential customers. You must start the process early in the year to give yourself enough time to sell the calendar promotion and to print it. February or March is ideal. Take deposits to help you pay for the printing, then deliver the finished product no later than Thanksgiving.

Find more great instruction from Jim Zuckerman and Writer's Digest Books!

Find invaluable instructions and advice to help you shoot successfully in any lighting situation imaginable! Every situation is covered, including working with snow, backlighting, fill flash, macro subjects, extreme contrast, and more. Beautifully illustrated with more than 200 nature photographs, this must-have reference enables you to master all the technical aspects of exposure, then create your own artistic effects!

**ISBN 1-58297-126-9, paperback,
160 pages, #10792-K**

This book focuses on the newest developments in the digital revolution of photography. For both the hobbyist and the professional, the "show-and-tell" instruction makes this exciting new technology both accessible and easy to understand. It also answers many of the questions facing digital photographers today, with photographic examples of effects ranging from the simple to the sophisticated.

**ISBN 1-58297-058-0, paperback,
144 pages, #10737-K**

Designed to help photographers create exciting, professional-looking images, from animals and flowers to broad landscapes, this guide covers a range of outdoor subjects and combines sound guidance with spectacular full-color images. Focusing on different photographic elements, such as color, texture, and form, you'll learn how these elements can be altered using filters, lighting and film stock to produce breathtaking results.

**ISBN 0-89879-991-0, paperback,
128 pages, #10675-K**

This is the essential guide for photographers who want to add stunning, beautiful color effects to their photographs. The captivating images embody the perfect union of light, composition and color. No matter what your photography skill, you'll learn how to capture the same beauty in your own work!

**ISBN 0-89879-800-0, paperback,
144 pages, #10552-K**

These and other fine Writer's Digest titles are available from your local bookstore, online supplier or by calling 1-800-448-0915.